450

Joseph Berglinger in Perspective

D1013881

European University Studies

Europäische Hochschulschriften
Publications Universitaires Européennes

**Series I
German Language and Literature**

Reihe I · Série I
Deutsche Sprache und Literatur
Language et littérature allemandes

Vol. / Band 851

PETER LANG
Berne · Frankfurt am Main · New York

John Ellis

Joseph Berglinger in Perspective

A Contribution to the Understanding of
the Problematic Modern Artist in
Wackenroder/Tieck's
"Herzensergiessungen eines
kunstliebenden Klosterbruders"

PETER LANG
Berne · Frankfurt am Main · New York

CIP-Kurztitelaufnahme der Deutschen Bibliothek

Ellis, John:
Joseph Berglinger in Perspective: A Contribution
to the Understanding of the Problematic Modern
Artist in Wackenroder/Tieck's «Herzens-
ergiessungen eines kunstliebenden Klosterbruders» /
John Ellis. – Berne; Frankfurt am Main;
New York: Lang, 1985.
 (European University Studies: Series 1,
 German Language and Literature; Vol. 851)
 ISBN 3-261-04056-4

NE: Europäische Hochschulschriften / 01

© Peter Lang Publishers Ltd., Berne 1985
Successors of Herbert Lang & Co. Ltd., Berne

Printed by Lang Druck Ltd., Liebefeld/Berne (Switzerland)

Dedication

For my grandfathers: Alec H. Ellis and, in memoriam, Albert
L. Barkshire, lost over German territory 7/8 August 1944.

Acknowledgment

I would like to express my thanks to Dr. Raleigh Whitinger for his kind assistance during all stages of the preparation of this thesis and to Peter Tyson and Nicole Davis for their help with the manuscript.

Table of Contents

1. Introduction

The *Herzensergiessungen eines kunstliebenden
Klosterbruders*, (Effusions from the heart of an art-loving
friar), was first published in the fall of 1796, though
bearing the date 1797, by Johann Friedrich Unger in Berlin.
It appeared anonymously, no doubt due to the retiring nature
of its major co-author, Wilhelm Heinrich Wackenroder
(1773-98). Indeed, it was not until 1799 when the lesser
contributor, Ludwig Tieck (1773-1853) published his
prematurely departed friend's literary bequest that the
identity of the true author became generally known.[1]

The authors could scarcely have forseen the impact
which this slim volume was to have on the German literary
scene.[2] In terms of literary history, the
Herzensergiessungen is generally regarded as the founding
work of German Romanticism. This is not to deny that the
current of Romanticism had already made its mark in German
literature, as indeed it had.[3] It is a simple fact, however,

[1]As I do not intend to take issue with the question of
authorship of individual sections of the work, I refer the
reader to Richard Alewyn, "Wackenroders Anteil an den
Herzensergiessungen und den *Phantasien*", *Germanic Review*, 19
(1944), 48-58.
[2]For the impact of the work in the field of painting, music
and philosophy, see Mary Ethel Hurst Schubert, "Wilhelm
Heinrich Wackenroder's *Confessions* and *Phantasies*:
Translated and annotated with a critical introduction",
Diss. Stanford, 1970, pp. 1-3.
[3]Witness Goethe's *Wilhelm Meisters Lehrjahre* (published
earlier in the same year), a work generally agreed to have
had seminal influence on Romanticism.

that the *Herzensergiessungen* is chronologically,
philosophically, thematically and structurally the inceptor
of that relatively independent strain of Romanticism: the
"Frühromantik". [4]

1.1 Strains of Wackenroder-criticism

A survey of secondary literature on Wackenroder reveals
three main areas of research. From the very beginning, there
has been a great deal of interest shown in his aesthetic
system. In recent times this has produced such studies as
Heinz Lippuner's *Wackenroder/Tieck und die bildende Kunst:
Grundlegung der romantischen Ästhetik* (Zurich: Juris, 1965);
David Sanford's "Wackenroder and Tieck: The aesthetic
breakdown of the Klosterbruder ideal" (Diss. Minnesota,
1966); Rose Kahnt's *Die Bedeutung der bildenden Kunst und
der Musik bei W. H. Wackenroder* (Marburg: Elwert, 1969) and
Marianne Frey's *Der Künstler und sein Werk bei W. H.
Wackenroder und E. T. A. Hoffmann: Vergleichende Studien zur
romantischen Kunstanschauung* (Bern: Lang, 1970). All of
these works have been a valuable source of stimulation for
the present study since they concern themselves necessarily,
to a greater or lesser degree, with the artist figures of
the *Herzensergiessungen* and the Klosterbruder's ideal.

A second strain of research has concerned itself with
Wackenroder's historical perspective. Of interest amongst

[4]These points will be discussed in the next chapter.

the more recent contributions in this area are William
Robson-Scott's article "Wackenroder and the Middle Ages" [5]
and Gudrun Horton's dissertation "Die Entstehung des
Mittelalterbildes in der deutschen Frühromantik:
Wackenroder, Tieck, Novalis und die Brüder Schlegel" (Diss.
Washington, 1973). The largest contribution of recent
decades, however, remains Dorothea Hammer's dissertation
"Die Bedeutung der vergangenen Zeit im Werk Wackenroders
unter Berücksichtigung der Beiträge Tiecks" (Frankfurt/Main,
1961). Not merely in the above works, but in general, there
is a regrettable tendency to over-simplify Wackenroder's
historical perspective in one important aspect. Whereas I
freely admit that there is a clear dichotomy between the
idealized past and the problematic present in the
Herzensergiessungen, it must be remembered that the artistic
spirit of the past still lives on in the modern era.

A third strain of Wackenroder-criticism has focused
more exclusively on the figure of the problematic modern
composer Joseph Berglinger as he appears in the
Herzensergiessungen (and its sequel, the *Phantasien über die
Kunst*). Of interest in this area are Paul Frank Proskauer's
dissertation "The Phenomenon of Alienation in the Works of
Karl Philipp Moritz, Wilhelm Heinrich Wackenroder and in
Nachtwachen von [sic] Bonaventura" (Diss. Columbia, 1966)
and Ruthann Richards' article "Joseph Berglinger. A radical

[5]*Modern Language Review*, 50 (1978), 124–39.

composer".[6] The most weighty contribution in this field is Elmar Hertrich's *Joseph Berglinger: Eine Studie zu Wackenroders Musiker-Dichtung* (Berlin: de Gruyter, 1969). These works reflect a general tendency to hurry forward to an analysis of the problematic modern artist of the *Herzensergiessungen* without paying sufficient attention to the earlier sections of the work. This leads in most cases to an inordinately negative evaluation of this most interesting figure.

In addition to the main trends mentioned above, there are two other areas of great interest. Because of the uncertainty surrounding the co-authorship of the *Herzensergiessungen*, many attempts have been made to determine which sections of the work may be attributed to which author. Finally, exhaustive research has been undertaken to identify Wackenroder's sources.

1.2 Thesis goal and approach

The prime aim of this thesis is to contribute to the understanding of the problematic modern composer Joseph Berglinger by viewing him within the total context of the *Herzensergiessungen*. It is my opinion that the tragic struggle of the problematic modern artist is intended to be seen within a historical perspective. The nature of the dilemma which Berglinger encounters cannot be fully

[6]Germanic Review, 50 (1978), 124—39.

understood unless he is compared to his spiritual forefathers of the Renaissance who were fortunate enough to belong to an age which was immeasurably more favourable to the Romantic artist.[7] If one fails to make this comparison, there is a danger that too much emphasis be placed on his inherent dispositional failings.

In order to counter the tendency of isolating the figure of Berglinger from the rest of the work, it is necessary, first of all, to demonstrate that the Berglinger-novella is an integral part of the whole work. Thus, the following chapter will constitute a structural and thematic analysis of the *Herzensergiessungen*. The subsequent chapter will analyse in detail the vitae of the Renaissance artists to form the basis of a later comparison between Berglinger and the artists of the past. The last main chapter will analyse the vita of Berglinger, who will then be compared to his fellow artists of the modern and Renaissance periods. There will be no attempt at any time to draw, as many critics have done, on the material from the *Phantasien*. This will ensure that the structural integrity of the *Herzensergiessungen* is strictly observed. At all times my analysis and my conclusions will be based on a close reading of the text. Every effort will be made to support my ideas with textual examples.

[7]Mary Schubert is one critic who has made a significant contribution in this regard. Mary Schubert, op. cit., passim.

2. Form and Structure of the *Herzensergiessungen*

In general, the complex, or rather the intricate
structure of the *Herzensergiessungen* has received little
attention.[8] Various superficial comments have been made
concerning genre. The work has often been seen as a loose
collection of disparate sections governed by a single
perspective and a common focus on art.[9] Despite the apparent
formlessness, however, there is a firm underlying structure
which binds the seemingly unconnected pieces together.

The more obvious structural features, such as the
framework, the novella-like form of the Berglinger-story,
and the three main time-levels (Renaissance, recent past,
and narrative present) are common intellectual property. The
latter, however, have been seen all too frequently in terms
of a total dichotomy between the idealized past and the
problematic present. In reality, the transition from the
golden age of the Italian Renaissance to the Germany of the
troubled modern artist is softened by numerous points of
similarity and cross-reference between Berglinger and the
artists of the past.

[8] The comments on the structure of the *Herzensergiessungen*
made by Mary Schubert constitute a notable exception. M. S.,
op. cit., pp. 70—79 and 99—125.
[9] Thus Lilian R. Furst, "a loose collection of nineteen (sic)
pieces all concerned with the holiness of art, all
rhapsodical in tone.", *Romanticism* (London: Methuen, 1969),
pp. 53—54.

The present chapter will discuss the
Herzensergiessungen firstly in terms of its relationship to
other important literary works of the early Romantic period
in Germany, and to the literary theories of Friedrich
Schlegel. Subsequent sections will examine the narrative
situation, the application of the framework technique,
elements of genre, the different time levels and the inner
structure. This will reveal that the arrangement of the work
is much less haphazard than it might seem. The purpose of
this undertaking is to cast new light on the relationship of
the various sections to each other and, in particular, to
illustrate the connections between the Berglinger-novella
and the other artist-vitae. Such a process averts the danger
of viewing the past and the narrative present merely in
terms of their incongruity, which is in fact only partial.

2.1 The *Herzensergiessungen* in its thematical and structural relationship to literature and literary theory of early German Romanticism

Preliminary insights into a work of literature are
often gained most easily by comparing it to other examples
of the movement or period to which it belongs. Thus, I turn
first of all to other literary and theoretical expressions
of the early Romantics in Germany.

Although the *Herzensergiessungen* distinguishes itself
from the other works of the "Frühromantik" by the amount of

factual and quasi-factual material which it contains, it deals with history in the same arbitrary fashion. In this respect as in many others, the *Herzensergiessungen* is eminently comparable to Tieck's *Franz Sternbalds Wanderungen* (1798) and Novalis' *Heinrich von Ofterdingen* (1799–1800). They all look back nostalgically to the Middle Ages or the Renaissance as to a utopian, pre-Enlightenment realm of greater artistry and stronger unity between God, Nature and mankind. Since the function of the past is largely symbolic, historicity has no great role to play. Wackenroder treats his source material fairly freely when it suits his purpose. Examples of this are the substitution of the Madonna for Galatea in "Raffaels Erscheinung", and the dramatization of Vasari's account of Piero di Cosimo.[10] In *Sternbald* Tieck uses some historical detail, especially with regard to the figure of Albrecht Dürer. In *Heinrich von Ofterdingen* history provides us with little more than the hero's name and the backdrop of the Crusades.

Within the idealized past these works focus on the role of art and the nature of the artist. In the scheme of Creation the artist is regarded as a mediator between the empyrean and worldly spheres. He alone among mankind is

[10]For details see Ernst Dessauer, "Wackenroders *Herzensergiessungen* in ihrem Verhältnis zu Vasari", in *Studien zur vergleichenden Literaturgeschichte* (Berlin, 1906–07), vol. VI, 245–70 and VII, 204–35 and Ladislao Mittner, "Galatea. Die Romantisierung der italienischen Renaissancekunst und -dichtung in der deutschen Frühromantik," *Deutsche Vierteljahrsschrift*, 27 (1953), pp. 555–81.

endowed with the supreme gift of being able to sense the
harmony which exists throughout all of Nature. This enables
him to translate the mystical language of Nature into a work
of art, thus providing an indispensable link between God and
the common run of man. Taken to its most extreme form this
view of the artist places him high above his fellows within
the scheme of Creation. Thus F. Schlegel's *Ideen-Fragment*
43:

> Was die Menschen unter den anderen Bildungen der
> Erde, das sind die Künstler unter den Menschen.[11]

Art is exalted to the same level as religion; its exponent
and representative, the artist, is then a kind of priest:

> Die Poesie ist die Sprache der Religion und der
> Götter.[12]

Similarly:

> Die einzige gültige Beglaubigung des Priesters ist
> die, dass er Poesie redet.[13]

The equation of art and religion is nowhere more clearly
stated than in the *Herzensergiessungen*. In Tieck's *Sternbald*
this unity is only implied. In *Heinrich von Ofterdingen* the
emphasis is on the supernatural qualities of the artist.

In all three works the decline of artistic powers is an
extremely important theme, though it is less clear in the

[11]Friedrich Schlegel, *Kritische-Friedrich-Schlegel-Ausgabe*,
ed. Ernst Behler (Munich, Paderborn, Vienna: Schöningh;
Zurich: Thomas, 1979), vol. II, p. 260.
[12]*Literarische Notizhefte*, Fragment 1261,
Kritische-Friedrich-Schlegel-Ausgabe, vol. XVI, p. 232.
[13]*Literarische Notizhefte*, Fragment 1820,
Kritische-Friedrich-Schlegel-Ausgabe, vol. XVI, p. 278.

case of *Sternbald*. In *Heinrich von Ofterdingen* this is
revealed through four carefully graded portraits of artistic
ability ranging from Fabel in Klingsohr's fairy-tale to
Ofterdingen himself. In the *Herzensergiessungen* there are
two distinct periods which are contrasted; the golden age of
the Renaissance and the troubled present. Thus in both of
these works the theme of decline becomes a structural
feature.

Other elements of structure in the *Herzensergiessungen*
are typical of early German Romantic literature in general.
The "Frühromantiker" rejected the standard novel form as a
mode of poetic expression in favour of one bound only by the
limitations of the writer's imagination. The most cogent
theoretical statements reflecting the call for a
revolutionary, all-encompassing literary form are found in
the writings of F. Schlegel. Of these, the section of the
Gespräch über die Poesie entitled "Brief über den Roman" and
the oft-cited 116th *Athenäums-Fragment* have representative
value. The "Brief über den Roman" praises Diderot's *Jacques
le fataliste* and the novels of Jean Paul and Sterne on
account of the colourfulness of their form. Such works,
earning the designation of "arabesque", are arranged
according to an overriding intellectual unity, and do not
depend on a rigid plot. In Schlegel's eyes the arabesque is
an essential form of poetic expression. Much greater praise
is bestowed on Ariosto, Cervantes and, especially,
Shakespeare, who are seen to be the foremost exponents of

the "Roman". Essentially, the "Roman" is considered to be a
mixture of story-telling, poetry, song and other modes of
expression. Moreover, the word "Romantic" does not apply so
much to a particular genre as to an element of poetry, which
ought never to be entirely absent from any work of
literature.

Schlegel regards the "Roman" as a literary form which
not only encompasses, but also transcends all literary
genres of past and present. This view is most clearly
expressed in the opening lines of the 116th
Athenäums-Fragment:

> Die romantische Poesie ist eine progressive
> Universalpoesie. Ihre Bestimmung ist nicht bloss,
> alle getrennten Gattungen der Poesie wieder zu
> vereinigen und die Poesie mit der Philosophie und
> Rhetorik in Berührung zu setzen. Sie will und soll
> auch Poesie und Prosa, Genialität und Kritik,
> Kunstpoesie und Naturpoesie bald mischen, bald
> verschmelzen, die Poesie lebendig und gesellig und
> das Leben und die Gesellschaft poetisch machen, den
> Witz poetisieren und die Formen der Kunst mit
> gediegnem Bildungstoff jeder Art anfüllen und
> sättigen und durch die Schwingungen des Humors
> beseelen. Sie umfasst alles, was nur poetisch ist,
> vom grössten wieder mehrere Systeme in sich
> enthaltenden Systeme der Kunst bis zu dem Seufzer,
> dem Kuss, den das dichtende Kind aushaucht in

kunstlosen Gesang. [14]

Among other things, this indicates that variety of modes of expression is one of the essential characteristics of the Romantic work. Thus the 116th *Athenäums-Fragment* agrees with Schlegel's other pronouncements on the structure of the "Roman" which call for it to be a "Mischgedicht" or "künstlich geordnetes Chaos".

Returning to the *Herzensergiessungen*, we find it to be the "Mischgedicht" par excellence since it displays a greater variety of genres than any other work of early German Romanticism. Moreover, it is also a "künstlich geordnetes Chaos". The remainder of this chapter will serve to illustrate these points.

2.2 The narrative situation and framework

The most obvious structural feature of the work is the application of the framework or "Rahmen" technique — one commonly associated with the novella. [15] This device is an extremely versatile means of establishing a given perspective which then governs the narrative. Essentially, it involves the creation of a fictional narrator (or narrators) who mediates between the story and the reader. Since this narrator is almost without exception someone for

[14] *Kritische-Friedrich-Schlegel-Ausgabe*, vol. II, p. 182.
[15] A lucid description of the framework technique in the German "Novelle" is given by Henry H. H. Remak, "Der Rahmen in der deutschen Novelle: Dauer im Wechsel", in *Traditions and Transitions*, eds. Kurth, McClain, Homann et al. (Bad Windsheim: Delp, 1972), pp. 246—62.

18

whom the story has a special significance, he does not
simply relate events, but "sustains a complex and reflective
relationship" to them.[16] This is precisely the narrative
situation which confronts us in the *Herzensergiessungen*.

Although the wording of the full title,
Herzensergiessungen eines kunstliebenden Klosterbruders,
appears to have been suggested by the publisher J. F.
Reichardt, the actual figure of the narrator is clearly the
brainchild of Wackenroder himself.[17] The preface "An den
Leser dieser Blätter" provides a clear outline of the
friar's nature and circumstances. Alienated by modern
society and its attitude toward art, he has long since
withdrawn from the world in order to end his days in the
solitude of a monastery. Here he looks back with nostalgia
on his youth and his experience of art. The polemical stance
of his reminiscences is determined by two factors; his
religious feeling for art and his antagonism toward the
prevailing insensitivity of his day.[18] This perspective
permeates the whole work and binds the various sections into
a meaningful entity.

[16]Martin Swales, *The German Novelle* (Princeton: University,
1977), p. 54.
[17]It is a point of contention whether the figure of the
Klosterbruder or merely the title of the work was suggested
by Reichardt. Cf. Richard Alewyn, op. cit., pp. 49-50.
[18]Cf. Rudolph Haym, *Die Romantische Schule. Ein Beitrag zur
Geschichte des deutschen Geistes* (1870; rpt. Darmstadt,
1961) and Werner Kohlschmidt, *"Der junge Tieck und
Wackenroder", p. 32, in Die deutsche Romantik*, ed. Hans
Steffen (Göttingen: Vandenhoeck and Ruprecht, 1967), p. 32.

There are two main focal points of the Klosterbruder's attention. The first of these is the Italian Renaissance, which he presents as the golden age of art. His own comments are given extra credence with the aid of a secondary, or extended framework consisting of material gleaned from the accounts of venerated art-historians such as Vasari.[19] Thus the role of chronicler is added to that of narrator. His account of the past is further substantiated with letters purportedly written by artists.

Once he has delivered his tribute to the Renaissance, he turns to the more recent past and the tragic figure of his friend Berglinger. Looking forward, the narrative situation here is an obvious parallel forerunner of that in Thomas Mann's *Doktor Faustus*. In both cases the fictional narrator is the intimate friend of a problematic composer, whose recorded life is curiously symptomatic of the fate of society as a whole.[20]

An examination of the narrative framework technique employed in the *Herzensergiessungen* reveals it to be extremely functional, not merely decorative. The figure of the Klosterbruder is not intended simply as a guise for the projection of Wackenroder's views on art and religion. One of his essential characteristics is that he maintains a

[19] For details of Wackenroder's sources see: Paul Koldewey, *Wackenroder und sein Einfluss auf Tieck* (Altona: Hammerich and Lesser, 1904), passim and Ernst Dessauer, "Wackenroders Herzensergiessungen in ihrem Verhältnis zu Vasari".
[20] Cf. Frank Proskauer, op. cit., pp. 191—92 and Elmar Hertrich, op. cit., p. 22.

particularly close relationship to the artists of the past
as well as to the modern problematic artist Berglinger. This
key position enables him to present the representative
figures of the two ages side by side with equal affection so
that the reader is forced to draw parallels between them.
The close affinity between the Klosterbruder and Berglinger
is particularly interesting since it leads inevitably to a
comparison of the ways in which these two artistic natures
are unable to adapt to modern society.

2.3 Time levels

As is well known, the Klosterbruder's perspective
operates on three distinct time levels: the distant past,
the recent past of living memory and the present.[21] As he
looks back from the narrative present, he reviews his
"Lieblingsgegenstand" in art, the Renaissance, in a series
of portraits of its greater representatives such as Raphael,
Leonardo da Vinci, Michelangelo and Dürer, as well as lesser
figures such as Francesco Francia, and fictional young
artists such as Antonio. A somewhat extended view of the
past is provided in the episode entitled "Die Malerchronik".
Interspersed among these are sections which focus on the
Klosterbruder's own youth, such as "Sehnsucht nach Italien"
and parts of the "Malerchronik". To an undefined period
between his youth and the present belongs the life-story of

[21]Cf. Elmar Hertrich, op. cit., pp. 14—15.

his friend Joseph Berglinger, to which he turns after completing his review of the more distant past.[22]

Each of these separate time levels has a symbolic function within the scheme of the work. The artists of the Renaissance and the "Malerchronik" belong to an idyllic age of artistic talent and universal enthusiasm for art, which, nevertheless, is not totally lacking in disquieting elements. In the period of the Klosterbruder's youth this spirit of the Renaissance lingers on, yet only in the hearts of a few individuals such as the Klosterbruder himself. It appears that an era of increasing rationalism towards art has intervened to dim the flame of artistic creativity. Emblematic of this decline is the troubled life of the modern artist Berglinger, whose difficulties are compounded by the problematic aspects of his own nature. The narrative present itself is an age where the Romantic artist is spiritually apart from society.

In general the various sections of the *Herzensergiessungen* are arranged according to structural requirements rather than any strict chronological order. Admittedly, the vitae of the Renaissance artists and the "Malerchronik" precede the Berglinger-story, yet within the past there is no historical sequence. The Klosterbruder is concerned with the spirit of the Renaissance, not its development. The past is presented en bloc as a flourishing golden age which contrasts deeply with the narrative

[22]ibid.

present. Thus, as already indicated, any observance of
historical truth or chronology is secondary to the thematic
structure of the work.

2.4 Elements of genre

The *Herzensergiessungen* is such a unique work that it
defies simple classification. It consists of a cycle of
eighteen pieces covering a variety of genres. Being a cyclic
work, it is related, if only by this formal aspect, to such
oeuvres as Boccaccio's *Decamerone*, Chaucer's *Canterbury
Tales*, Goethe's *Unterhaltungen deutscher Ausgewanderten* and
F. Schlegel's *Gespräch über die Poesie*. [23] These, however,
include a number of viewpoints as opposed to the single,
maintained perspective of the Klosterbruder.

The structural organization of the *Herzensergiessungen*
becomes clearer if the various sections are first classified
into groups of similar pieces. The prose sections fall into
four readily identifiable sub-genres. The largest single
group comprises the artist-vitae of Raphael, Francesco
Francia, Leonardo da Vinci, Dürer, Piero di Cosimo and
Michelangelo. To these may be added the more general
"Malerchronik". Each of these "biographies" is a variation
on a standard pattern. The short introductory statement by
the Klosterbruder generally praises a certain aspect of the
Renaissance which is then contrasted with the modern age.

[23] Cf. Mary Schubert, op. cit., p. 70.

For example, the introduction to "Raffaels Erscheinung" is immediately followed by a jeremiad against modern theoretical treatises on art. This technique of comparison between past and present is sustained by means of further interpolations. The aspect of Renaissance greatness glorified in the introduction is exemplified in the vita of the artist concerned. In some cases there is a dramatic incident which seems to crystallize or typify one essential aspect of his nature. Examples of this are Raphael's revelation, Francia's confrontation with a vastly superior talent and Cosimo's carnival procession. The "Malerchronik" proceeds in a similar fashion, though it depicts a number of artists. This element of the "unerhörte Begebenheit" provides a close link to the novella genre.

A second group consists of the three letter-episodes "Der Schüler und Raffael", "Ein Brief des jungen Florentinischen Malers Antonio an seinen Freund Jacobo in Rom" and the "Brief eines jungen deutschen Malers in Rom an seinen Freund in Nürnberg." As Mary Schubert points out, these belong clearly to the tradition of the "Briefroman".[24] Indeed, as is the case with a number of works of this type, it is a question here of young artists confiding in a friend or mentor.[25] The first two episodes, both of which focus on the figure of Antonio, include replies. The third episode is

[24] Mary Schubert, op. cit., pp. 72–73.
[25] One thinks immediately of Goethe's *Werther*.

a Sternbaldian letter to Sebastian, which appears alone. [26]

The third group consists of three polemical sections or essays: "Einige Worte über Allgemeinheit, Toleranz und Menschenliebe in der Kunst", "Von zwei wunderbaren Sprachen und deren geheimnisvoller Kraft" and "Wie und auf welche Weise man die Werke der grossen Künstler der Erde eigentlich betrachten und zum Wohle der Seele gebrauchen müsse". [27] To these one might add the polemically phrased preface "An den Leser dieser Blätter". Each of these sections elaborates on a certain aspect or aspects of the Klosterbruder's credo and attacks the modern view of art.

Before considering the fourth and final prose genre of the *Herzensergiessungen*, as represented by the Berglinger-novella, I now turn briefly to the lyrical sections of the work. The first of these, "Sehnsucht nach Italien", is in fact part prose and part lyric verse. Both pieces give expression to the same longing in the Klosterbruder's heart. "Zwei Gemäldeschilderungen" is the Klosterbruder's lyrical appreciation of two beautiful paintings. "Die Bildnisse der Maler" is his lyrical tribute to his four favourite Renaissance artists; Raphael, Dürer, Michelangelo and Leonardo da Vinci. In common with all lyric verse, these sections express a feeling as opposed to describing any outward event.

[26] I refer, of course, to Tieck's *Sternbald*.
[27] Cf. Werner Kohlschmidt, *Die deutsche Romantik*, ed. Hans Steffen, p. 35 and Mary Schubert, op. cit., p. 77.

The Berglinger-story itself satisfies the basic requirements of the "novella" genre. It is a short, poignant narrative work, which, like many of its type, employs the framework technique and focuses on an enigmatic figure and the unusual events which surround him. Moreover, it may be seen within the tradition of the German "Künstler-Novelle", with its emphasis on the artist's estrangement from society. Like the oeuvre of which it is a part, the Berglinger-story has a complex structure. Indeed, it incorporates all the modes of expression found in the *Herzensergiessungen* (i.e. prose, lyric verse, letter, polemic). Although considerably longer than the other artist-vitae, it deals with the central figure in the same fashion. The story is divided into two parts which focus on Berglinger's boyhood and adult life respectively.

2.5 Inner balance and structure

Further light may be shed on the structure if certain sections are temporarily set aside. If one disregards the preface, "Raffaels Erscheinung", the "Malerchronik" and the Berglinger-story, it is possible to discover an inner balance to the *Herzensergiessungen*. The remaining pieces seem to be arranged around the panegyric of Albrecht Dürer.[28] This central episode is immediately flanked by the two "theoretical" pieces to which it is thematically

[28] Cf. Richard Benz, "Nachwort" to *Herzensergiessungen* (Stuttgart: Reclam, 1979³), p. 132.

related; "Einige Worte über Allgemeinheit, Toleranz und Menschenliebe in der Kunst" and "Von zwei wunderbaren Sprachen und deren geheimnisvoller Kraft". Indeed, the first of these, with its plea for the universal validity of art, prepares the way for the inclusion of Dürer among the Renaissance greats. On either side, though by no means symmetrically arranged, are the vitae of one great Renaissance artist (Leonardo da Vinci/Michelangelo) and one problematic Renaissance artist (Francesco Francia/Piero di Cosimo). Furthermore, the third of the letter episodes provides something of a counterbalance to the first two on the opposite flank. Also, the main body of the work (apart from the introduction), beginning and ending with Raphael and Berglinger respectively, seems to balance the ideal Renaissance artist with a problematic modern artist.

In addition, the position of certain sections appears to be directly related to their function within the *Herzensergiessungen*. This is particularly true of "Raffaels Erscheinung", the Dürer episode, the "Malerchronik" and the Berglinger-story. It would seem essential that the vita of Raphael be placed first so that the other artists may be seen within the perspective of the ideal. The central position of Dürer is very apt on account of the link mentioned above. The "Malerchronik" is suitably located at the end of the sections dealing with the past and immediately before the Berglinger-story. It presents a summary of the past and runs through the whole gamut of

artistic genius from the sublime (Raphael) to the
problematic (Spinello), thus portraying the duality of the
artistic spirit which Berglinger subsequently embodies. The
Berglinger-story itself naturally concludes the oeuvre,
since the problematic present must be seen in the light of
the past.

2.6 Concatenation

The concatenation of recurring interrelated motifs,
images, metaphors and personal characteristics is an
extremely important structural and thematic feature of the
work. This literary technique has often been compared to the
symphonic form. [29] In the *Herzensergiessungen*, this
structural principle is most evident in the artist-vitae and
the Berglinger-story, where many similarities and subtle
comparisons may be found between the various artist figures.
To their credit, many critics have commented on the
similarities between Berglinger and the problematic artists
of the Renaissance, yet relatively few have gone further in
this direction. The most significant contribution in this
area has been made by Mary Schubert. She comments that
Wackenroder "... mirrors one artist in the reflection of
another ..." and "... contrasts the various artists whom he
has selected for close examination." [30] Her consideration of
the "thematic" structure of the *Herzensergiessungen* has been

[29] Cf. Mary Schubert, op. cit., p. 98.
[30] ibid., p. 118.

particularly successful in revealing Wackenroder's use of
metaphors of light and darkness throughout the artists'
biographies. [31] Ultimately, there exists a web of common
traits linking Berglinger not only to the problematic
artists of the past, but also to the divine artists such as
Raphael. These factors, together with the juxtaposition of
past and present, are a clear indication of Wackenroder's
intention of inviting a comparison. The two eras and their
representatives must be weighed against each other. It is
not possible to arrive at a valid judgement of the
latter-day artist Berglinger without first comparing him to
the various artists of the idealized past, always bearing in
mind that the circumstances of the modern age are not
conducive to artistic creativity. It seems surprising,
therefore, that critics have tended to see past and present
more in terms of a crass dichotomy. A close examination will
reveal that their view must be qualified.

2.7 Conclusions

The present chapter has demonstrated that the
Herzensergiessungen, though seemingly chaotic in its
organization, is in fact a structured work of great
complexity. Moreover, since it stands at the head of the
"Frühromantik" chronologically, it is possible to surmise
that subsequent early German Romantic literary works and

[31] ibid., pp. 99—125.

literary theory owe a good deal to its example.

Having indicated the close connections between the artist figures of the past and Berglinger, it would now seem appropriate to examine these in detail before considering the problematic present. Thus I now turn to the vitae of the Renaissance artists and the thematically related "Malerchronik".

3. The artists of the Renaissance

As already indicated, the Klosterbruder's paean of the
Renaissance consists of a series of artist-vitae. On closer
examination, it appears that the artists concerned fall into
three distinct groups: ideal, ambivalent and problematic
artists. Moreover, within these sub-groups, it seems that
some are closer to the ideal than others. It is hoped that a
"ranking" of these artists according to this scheme will
help to reveal the similarities and differences between them
more clearly than their ordering in the *Herzensergiessungen*
allows.

3.1 The ideal artists

Notwithstanding the significance that it has for the
work, the Klosterbruder's definition of the ideal artist is
never clearly stated. There are fair indications, however,
that the ideal artist must embody the perfect union of
artistic creativity and Christian piety, and should receive
his inspiration directly from God. Werner Kohlschmidt
expresses it thus:

> ein biographisches Idealbild einer Genialität, die
> gleichbedeutend mit Frömmigkeit, einer

treuherzig-biederen Moralität und Humanität ist.[32]
As Kohlschmidt goes on to say, this ideal is most clearly
embodied by Raphael and (to a lesser degree) by Dürer.
Indeed, in the Klosterbruder's eyes, the name of Raphael is
practically synonymous with the ideal.

3.1.1 Raphael

The figure of Raphael and his example pervade the whole
of the *Herzensergiessungen*. His name appears in no less than
eleven of the eighteen sections. In others he is referred to
with his byname "der Göttliche" or the metaphor of a quietly
flowing stream. His function within the work is well known.
Stated simply, it is to stand as an example of the perfect
artist; a synthesis of artistry and piety. His many
appearances serve to recall the ideal and provide a standard
against which the other artists may be measured. Indeed, in
most instances he is compared explicitly or implicitly to
one or more of their number. This is true of the sections
dealing with Francia, Antonio, Leonardo, Dürer, Michelangelo
and Berglinger as well as the "Malerchronik". An examination
of every single one of his appearances is not considered
necessary here since his image remains the same throughout.
Rather, it would seem better to concentrate on this
extremely important character as he is revealed in the only
section devoted entirely to him, in which his special

[32]Werner Kohlschmidt, *Die deutsche Romantik*, ed. Hans
Steffen, p. 34.

qualities are shown most clearly.

In the introduction to "Raffaels Erscheinung", the
Klosterbruder broaches a topic which he portrays as being
highly controversial: the nature of artistic inspiration. In
his opinion, any denial of the truth concerning this matter
is tantamount to sacrilege. Most at fault are modern writers
who claim to know all of its secrets. In addition, there are
"unbelievers" who deny that there is anything divine in
enthusiasm for art. The Klosterbruder wishes to correct such
heretical beliefs which corrupt the young by imputing human
achievement to something that may only be gained with divine
assistance. The many accounts by artists which attest to
such heavenly inspiration have convinced him that they are
signs of that which is most holy in art: the direct
intervention of God. The story of Raphael which he proceeds
to relate is to provide self-evident proof of God's unknown
miracles.

He supports his claim by furnishing documentary
evidence. The first document is in the form of a letter from
Raphael to the Count of Castiglione, in which the artist
writes that, there being a scarcity of beautiful women, he
relies on a certain image which enters his mind. The
Klosterbruder sees the true significance of this statement
in an old manuscript from the hand of Bramante, in which
Raphael tells of his innermost secret. Asked whence he
derives the incomparable beauty and expression in his
paintings of the Madonna and the holy family, the humble,

bashful artist is moved to tears. He confesses the special
love which he has felt for the Madonna since childhood. As a
painter, his deepest wish has always been to depict her in
all her splendour. Try as he might, he has never been able
to succeed, yet occasionally and only momentarily a ray of
heavenly light will enter his soul and reveal her image to
him. Once, after having prayed to her in a dream, he awakes
suddenly to see his unfinished composition of the Madonna
become a complete, living portrait. The most astonishing
thing is that she appears exactly as the image of her in his
mind. This image now remains with him so that he is able to
finish the picture.

Raphael emerges in this vignette as an extremely modest
and sensitive individual. He is unwilling at first to
disclose the secret of his special gift. There is little
mention of his own part in the creative process. He
recognizes fully the passive role of the artist as a vessel
through which the glory of God is manifested. Indeed, he is
so cognizant of the divine influence in his works that he
stands in awe before them (p. 15).[33] He is the definitive
artist because he embodies so perfectly the union of art and
religion which constitutes the Klosterbruder's credo.
Through Raphael's example it is evident that enthusiasm and
imagination are not enough if an artist is to be considered

[33]All quotations from the *Herzensergiessungen* are taken from
the following edition: Wilhelm Heinrich Wackenroder, *Werke
und Briefe* (1797; rpt. Heidelberg: Schneider, 1967).
Henceforth this edition will be referred to by page number
alone.

truly great; he must also reflect Christian faith and values
in his life-style and must possess the ultimate gift of
divine inspiration.

3.1.2 Dürer

Albrecht Dürer is the only non-Italian to figure
largely among the Renaissance greats of the and the episode
concerning Leonardo da Vinci. Moreover, he plays an
important role in two other pieces and is mentioned towards
the end of the Berglinger-story.[34]

In several respects, the "Ehrengedächtnis unsers
ehrwürdigen Ahnherrn Albrecht Dürers" differs somewhat from
the other artist-vitae. Most noticeable is the greater
amount of polemic against the modern view of art.
Furthermore, there is no extraordinary event in which the
artist's essential characteristics are crystallized. As in
"Raffaels Erscheinung" and the section on Michelangelo,
there is relatively little biographical detail. There is,
however, much attention to Dürer's unique style.

The Klosterbruder begins his account by presenting the
city of Nuremberg as the cradle of German art, and by
pointing to Dürer as her greatest son. He then proceeds to
describe the features of Dürer's work which attract him
most. His art is based on real life, not on artificial
aesthetic principles. Each of his figures is a living,

[34] Dürer appears in "Brief eines jungen deutschen Malers in
Rom an seinen Freund in Nürnberg" and in "Die Bildnisse der
Maler".

speaking individual who displays genuine human emotion. The
Klosterbruder is drawn by the simplicity and expression in
his works:

> Ich liebe dich in deiner unbefangenen Einfalt, und
> hefte mein Auge unwillkürlich zuerst auf die Seele
> und tiefe Bedeutung deiner Menschen ... (p. 61)

These qualities are reminiscent of Raphael's style:

> Bei beiden gefiel es mir so sehr, dass sie so
> einfach und grade, ..., uns die Menschheit in voller
> Seele so klar und deutlich vor Augen stellen. (p.
> 64)

Significantly, the two artists are also very similar in
terms of their disposition and way of life.[35] Both lead a
simple, quiet and devout existence. Moreover, they are both
possessed of almost childlike innocence.

There is, however, one essential difference between the
two artists. Whereas Raphael's compositions are holy images,
those of Dürer portray ordinary people:

> Er war für das Idealistische eines Raffaels nicht
> geboren ... (p. 63)

Although this is in no way intended as a criticism of Dürer,
Raphael is clearly the more revered of the two on account of
his greater spirituality. Nevertheless, Dürer comes nearer
to achieving the Klosterbruder's ideal than the great
Italian artists Michelangelo Buonarroti and Leonardo da

[35] The similarities between Raphael and Dürer are well
documented in Wackenroder literature.

Vinci, even though he may not be on the same level of
technical mastery.

3.2 The ambivalent artists

In the *Herzensergiessungen*, there are two major artists
of the Italian Renaissance who present the reader with
something of a paradox. Even though the Klosterbruder never
questions the "sanctity" of Michelangelo and Leonardo, there
are certain aspects of their natures which are difficult to
reconcile with his concept of the ideal. Both appear to
combine qualities of the ideal artists with a few
potentially problematic ones. As one critic says, they
embody the ideal "... mit gewissen unheimlichen Zügen
gemischt." [36] Because of this element of ambivalence, they
appear to belong together in a category of their own.
Indeed, they are very similar in many respects. The marginal
differences between them, however, seem to indicate that
Michelangelo is closer to the ideal than Leonardo.

3.2.1 Michelangelo.

As is the case with the section on Dürer, "Die Grösse
des Michelangelo Buonarroti" focuses on the artist's unique
spirit and style without relating any particular incident
from his life. Like the ideal artists, he receives virtually
unqualified praise from the Klosterbruder. However, even

[36] Werner Kohlschmidt, *Die deutsche Romantik*, ed. Hans
Steffen, p. 34.

though he has much in common with Raphael and Dürer, there
are some disquieting aspects to his nature. Of course, these
negative characteristics are clearly outweighed by positive
ones, yet they take on significance when seen in the light
of genuinely problematic artists, such as Piero di Cosimo,
to whom they are also attributed.

The Klosterbruder begins his tribute to Michelangelo by
pointing once again to the Italian Renaissance as his
particular favourite within the realm of art. The artist on
whom his gaze now falls has been the object of unrestrained
admiration as well as scorn. An extremely positive view of
Michelangelo is given here in the form of the account of his
friend Vasari, who claims that this man was sent by God to
stand as an example of perfection in all branches of art:

> -da beschloss er, ..., einen Geist auf die Erde
> herabzuschicken, welcher durchaus, in jeglichem
> Teile aller Kunst, durch eigene Kraft sollte Meister
> werden. (p. 84)

Thus, like Raphael, he is considered as the bearer of a
divine message. He excels not only as a painter, but also as
a sculptor and architect. Moreover, like the ideal artists,
he is also an example of Christian virtue and moral wisdom:

> Überdas aber wollte der Himmel ihm die wahre
> Tugendweisheit zur Begleitung, und die süsse Kunst
> der Musen zur Zierde geben, auf dass die Welt ihn
> vor allen bewundern und erwählen sollte zum Spiegel
> und Muster im Leben, in Werken, in Heiligkeit der

Sitten, ja in allem irdischen Wandel, und er von uns

viel mehr für ein himmlisches Wesen als für ein

irdisches geachtet werden möchte. (p. 84)

Not to be satisfied simply with a statement of his own
admiration for Michelangelo, the Klosterbruder seeks to
penetrate his inner spirit and approach the unique character
of his works. In his opinion, each artist gives expression
to his soul through his art. Some animate their paintings
with quiet composure, others with exuberant force. This is
the very distinction he finds between the "divine" Raphael
and the "great" Buonarroti. He sees the former as being
blessed with the silent, heavenly spirit of Christ, and the
latter as being endowed with the inspiration of the
prophets. Just as the inspired oriental poets were driven to
extraordinary fantasies, so is the spirit of Michelangelo
captivated by the unusual and the monstrous:

... so ergriff auch die Seele des Michelangelo immer

mit Macht das Ausserordentliche und Ungeheure und

drückte in seinen Figuren eine angespannte,

übermenschliche Kraft aus. (p. 86)

Furthermore, he takes pleasure in depicting strange and
wonderful subjects:

Er versuchte sich gern an erhabenen, furchtbaren

Gegenständen; er wagte in seinen Bildern die

kühnsten und wildesten Stellungen und Gebärden; (p.

86)

Although the Klosterbruder does not criticize Michelangelo

for his wild fantasy, exuberance and choice of subjects, it must be noted that he deplores such characteristics in other artists of the *Herzensergiessungen*. He states elsewhere that it is the duty of the artist to reflect Nature in a beautiful fashion, not in abstractions and aberrations. Moreover, he should use art to glorify Creation, not to satisfy and express the power of his own spirit as Michelangelo does "... um die üppige Fülle seiner Geisteskraft ... auszulassen und zu befriedigen" (p. 86).

3.2.2 Leonardo da Vinci

In the introductory statement to "Das Muster eines kunstreichen und dabei tiefgelehrten Malers, vorgestellt in dem Leben des Leonardo da Vinci", the Klosterbruder hails the great artists of the Italian Renaissance as saints to whom altars have been erected in the temple of art. From their number he selects Leonardo da Vinci as a model of true erudition in the world of art. His example is to serve as proof that the genius of art may easily be paired with wisdom, and that a receptive spirit may reflect the sum of human knowledge in perfect harmony.

At first there seems to be little grounds for calling the Klosterbruder's apraisal of Leonardo into question. The early signs of his budding artistry are encouraged by his father, who apprentices him to the variously talented Verocchio. Thus, in addition to painting, sculpture and architecture, the young artist's mind is opened to music and

the science of mathematics. Through patient study and with a
tenacity equal to that of Dürer, Leonardo is able to excel
in all the branches of art and science.[37] Being blessed with
a body to match his mind, he also distinguishes himself in
every form of physical recreation. Moreover, like
Michelangelo, he is also a model of decorous behaviour. Of
all the fields of human endeavour, the art of painting is
closest to his heart. To this he applies himself with a
special fervour and desire for perfection. Through his study
of the laws of colour, perspective and proportion he becomes
a master of technique. He is a keen observer of Nature and
human anatomy, and, like all the great artists, he is able
to instil spirit and feeling into his compositions. Unlike
Raphael, Dürer and Michelangelo, however, he is not credited
explicitly with divine inspiration, even though he seeks it
when he cannot complete the figure of Judas in his painting
of the Last Supper (p. 43). His serene and noble death in
the arms of the King of France, however, is seen by the
Klosterbruder as the "apotheosis" of the artist (pp. 44—45).

Notwithstanding the extremely positive picture of
Leonardo given by the Klosterbruder, there are certain
questionable aspects to his nature which are not completely
obscured in the general flow of praise, even though these
are explained away or rendered innocuous. An example of this
may be seen in the Klosterbruder's explanation of Leonardo's
tendency to portray unnatural subjects:

[37]Cf. Heinz Lippuner, op. cit., p. 55.

Da seine Einbildung so fruchtbar und reif an
allerlei bedeutenden und sprechenden Bildern war, so
zeigte sich in seiner lebhaften Jugend, wo alle
Kräfte sich mit Gewalt in ihm hervordrängten, sein
Geist nicht in gewöhnlichen, unschmackhaften
Nachahmungen, sondern in ausserordentlichen,
reichen, ja fast ausschweifenden und seltsamen
Vorstellungen. (p.36—37)

As will be demonstrated, similar manifestations of overripe
imaginative powers are condemned elsewhere in the
Herzensergiessungen, particularly in the episode concerning
Piero di Cosimo. The same applies to Leonardo's restlessness
of spirit:

So hatte sein Geist einen angebornen Reiz, immer
etwas Neues zu ersinnen, der ihn in beständiger
Tätigkeit und Anstrengung hielt. (p. 40)

Furthermore, like Michelangelo, Leonardo takes pleasure in
portraying unusual physiognomical characteristics:

Es gefielen ihm vorzüglich wunderliche Angesichter
mit besonderen Haaren und Bärten ... (p. 39)

The Klosterbruder does indicate, however, that such excesses
were prevalent only in the artist's youth:

Die Erfahrenheit der Jahre ordnete nachher diesen
wilden, üppigen Reichtum in seinem Geiste (p. 39)

It is interesting to note that the Klosterbruder
chooses to indicate a distinction between the artist in
question and the divine Raphael, just as he did in the case

of Dürer and Michaelangelo:

> Wer bei meinem zweifachen Bilde, wie ich, an den
>
> Geist des Mannes, den wir eben geschildert haben,
>
> und an den Geist desjenigen, den ich den Göttlichen
>
> zu nennen pflege, gedenkt, wird in dieser
>
> Gleichnisrede vielleicht Stoff zum Nachsinnen
>
> finden. (pp. 45—46)

One may only surmise that the major difference lies therein
that Leonardo, like Michelangelo, allows imagination and
restlessness to reign over inspiration and composure.

3.3 The problematic artists

The third group of Renaissance artists in the
Herzensergiessungen comprises those who are partially or
essentially problematic in nature. Francesco Francia fails
to attain the ideal because of excessive pride. Piero di
Cosimo has an overwhelming preponderance of dubious
qualities. The fictitious young artist Antonio is
insufficiently gifted for his calling. Francia, Cosimo and
the other problematic artists are criticized in the
"Malerchronik", where it is said of Raphael:

> Er hatte nichts von dem finstern und stolzen Wesen
>
> anderer Künstler, welche manchmal mit Fleiss
>
> allerhand Seltsamkeiten annehmen ... (p. 101)

This alerts the reader to some basic differences between the
problematic artists and their more fortunate brethren. There

is, however, no absolute, clearly defined line of separation
between them. As already shown, even the great Michaelangelo
and Leonardo have some questionable qualities. Conversely,
positive characteristics are also ascribed to problematic
artists. This is particularly true in the case of Francia.

In recognition of their importance for a full
understanding of the modern problematic artist Joseph
Berglinger, the sections pertaining to Cosimo and Francia
will be discussed in greater detail than the other
artist-vitae.

3.3.1 Francesco Francia

The episode entitled "Der merkwürdige Tod des zu seiner
Zeit weitberühmten alten Malers Francesco Francia", placed
as it is shortly after "Raffaels Erscheinung", invites the
inevitable comparison of Francia to his illustrious
contemporary and confrère. Indeed, as Rose Kahnt indicates,
the story of Francia serves to embellish the impression
already gained of Raphael. His greatness is underpinned by
Francia's recognition of his infinite superiority — the two
artists appear in a contrastive light.[38] Thus, Marianne Frey
refers to Francia as yet another "Gegenbild zum Ideal".[39]
This is true, yet it is important to bear in mind that
Joseph Berglinger, not Raphael, is the central figure of the
work. For this reason, it is not enough to compare Francia

[38] Cf. Rose Kahnt, op. cit., p. 77.
[39] Marianne Frey, op. cit., p. 43.

to Raphael alone in the manner of some critics. In reality there are several factors which link Francia directly to Berglinger. Indeed, Mary Schubert has referred to Francia as "a spiritual predecessor of Joseph Berglinger".[40] In point of fact, Francia seems to occupy a position somewhere between Raphael and Berglinger on the Klosterbruder's scale of artistic greatness: he approaches the ideal in some respects, yet in others he is an obvious parallel to the problematic modern artist.

Nevertheless, the story of Francia begins on a highly positive note. The Klosterbruder's introductory statement consists of a eulogy of the Italian Renaissance as the true heroic age of art, interspersed with criticism of the modern age. Among the heroes of the Renaissance remarkable things were wont to occur due to universal enthusiasm for art:

> Es geschahen unter ihnen ungewöhnliche und vielen
> jetzt unglaubliche Dinge, weil der Enthusiasmus, der
> itzt nur in wenigen einzelnen Herzen wie ein
> schwaches Lämpchen flimmert, in jener goldenen Zeit
> alle Welt entflammte. (p. 18)

This enthusiasm and the lamentable lack thereof in the narrative present place a spiritual void between the two ages. Those of the degenerate modern era disbelieve and ridicule the tales of unusual happenings in the golden age of art because "the divine spark has fled their souls".

[40] Mary Schubert, op. cit., p. 97.

Francia, then, is evidently to be considered as one of
the Renaissance heroes; a founder, a creator and an
enthusiast. Even the strange events which surround him are
to be regarded as side-effects of an unequivocally laudable
quality: enthusiasm for art. The Klosterbruder proceeds to
herald the tale of Francia as one of the most uncanny of its
kind which, however, never gave him reason for doubt:

> Eine der merkwürdigsten Geschichten dieser Art, die
> ich nie ohne Staunen habe lesen können, und bei der
> mein Herz doch nie in Versuchung zu zweifeln geführt
> ward ... (p. 19)

The biographical detail begins with the artist's youth. Born
of a lowly artisan family, Francia is apprenticed to a
goldsmith and soon astounds everyone with the artistry of
his work. For a long time he designs commemorative coins, so
well that all the princes and dukes of his native Lombardy
make it a point of honour to have their images engraved by
his hand. Constant success and praise begin to have a
psychological effect on him. His aspiring nature is egged on
to seek new areas in which to excel:

> Aber Francescos ewig beweglicher, feuriger Geist
> strebte nach einem neuen Felde der Arbeit, und je
> mehr seine heisse Ehrbegier gesättigt ward, desto
> ungeduldiger ward er, sich eine ganz neue, noch
> unbetretene Bahn zum Ruhme aufzuschliessen. (p. 19)

His restless, ambitious spirit stands in stark contrast to
the placid, humble nature of Raphael and Dürer. His

all-embracing ability, however, links him to Michelangelo
and Leonardo.

At the age of forty, eager to try his hand at something
new, Francia turns to the art of painting. Like Leonardo, he
exercises extreme patience whilst acquiring the technical
skills of his profession. He progresses so swiftly that his
compositions, which amaze all Bologna, are counted amongst
the most distinguished of their time. In Lombardy he is the
first to lay the foundations of Renaissance art. He becomes
a prolific painter who produces countless beautiful works.
Word of his achievement spreads and his fame resounds
throughout the whole of Italy. Even Raphael honours him with
letters expressing his admiration.

The Klosterbruder, who views Francia from a totally
sympathetic standpoint, seeks to mitigate his pride by
explaining that this whole generation of artists enjoyed
universal esteem. The fact that Francia comes to believe in
a divine genius within himself is seen as the natural result
of the adulation coming from all sides:

Was konnten diese wiederholten Schläge anders für

eine Wirkung auf das Gemüt unsers Francesco haben,

als dass sein lebhafter Geist sich zu dem edelsten

Künstlerstolze emporhob und er an einen himmlischen

Genius in seinem Inneren zu glauben anfing. (p. 21)

Moreover, the Klosterbruder explains that Francia, unlike
modern artists, shows pride in his artistry, not in his own
person. Be this as it may, it must be noted that fame has no

adverse effects on artists such as Raphael, Dürer,
Michelangelo and Leonardo.

Francia's ultimate realization of the truth is all the
more painful because it is sudden, totally unexpected and
humiliating. Having regarded himself as virtually peerless
with the possible exception of Raphael, he is devastated by
inescapable proof of the other's divine gift and vastly
superior talent. In his old age, he is given his first
opportunity of seeing one of Raphael's paintings. The latter
informs him that his recently completed composition
portraying St. Cecilia is destined for the altar of a church
in Bologna. With all humility, he asks Francia to supervise
the handling of the work and to undertake any repairs or
improvements deemed necessary. Thus, Francia is hardly
prepared for the shock which awaits him. On hearing of the
arrival of the altarpiece, he rushes into his studio where
it has been placed in the most favourable light. The effect
it has on him is best described in the words of the
narrator:

> Es war ihm, wie einem sein müsste, der voll
> Entzückung seinen von Kindheit an ihm entfernten
> Bruder umarmen wollte, und statt dessen auf einmal
> einen Engel des Lichts vor seinen Augen erblickte.
> (p. 22)

With a rueful, broken heart he stands as if transfixed by
the splendour of the heavenly painting.

Significantly, his students cannot fathom his reaction since they are incapable of appreciating the divine quality of Raphael's art.[41] This ability to recognize the divine gift where others cannot may be indicative of his relative state of grace. Be this as it may, the startling revelation has disastrous consequences for Francia. He reproaches himself bitterly for his arrogance in placing himself above the incomparable Raphael, and is moved tragically to look back on his artistic achievements as a lifetime of foolish ambition and botchery. Moreover, being conscious of the spiritual sin of pride which he has committed, he raises his eyes towards heaven and begs humbly for forgiveness. The terrible blow to his self-esteem begins to undermine his mental constitution. Indeed, the confused state of feverish fantasy in which he ends his days is not unlike that of the aged Cosimo:

> Alle die unendlich mannigfaltigen Bildungen, die
> sich von jeher in seinem malerischen Sinn bewegt
> hatten, fuhren jetzt, mit verzerrten Zügen, durch
> seine Seele, und waren die Plagegeister, die ihn in
> seiner Fieberhitze ängstigten. (p. 23)

Nevertheless, the Klosterbruder's final appraisal of Francia is very positive. The regained humility which he reveals by acknowledging the superiority of Raphael's art over his own is interpreted as a sign of greatness:

[41]Cf. Erdmann Waniek, "Moritz-Wackenroder: Zur Problematisierung des künstlerischen Bewusstseins" (Diss. Oregon, 1972), p. 128.

So ward dieser Mann erst dadurch recht gross, dass

er sich so klein gegen den himmlischen Raphael

fühlte. (p. 23)

Moreover, he is regarded as one of the saints of art and a
true martyr of enthusiasm for art. There remains no doubt
but that he has certain qualities in common with the great
artists already mentioned. As the father of his own school
of painting in Lombardy, he belongs to the ranks of the
great originals. In a limited fashion, he too is party to
divine inspiration.[42]

These positive characteristics, however, cannot obscure
the problematic aspects of his disposition. He remains the
prime example of the artist whose painstakingly acquired
mastery leads to excessive pride.

3.3.2 Piero di Cosimo

The vita of the partially problematic artist Francesco
Francia gives the reader the impression that the idealized
past is perhaps not quite as perfect as the Klosterbruder
had led him to believe. This feeling is substantiated in the
section entitled "Von den Seltsamkeiten des alten Malers
Piero di Cosimo aus der Florentinischen Schule", the story
of the most extraordinary and questionable artist figure of
all those considered in the *Herzensergiessungen*.[43] Once

[42] Cf. Rose Kahnt, op. cit., p. 90.
[43] According to Heinz Lippuner, Wackenroder sees Cosimo as a
"Gegenbeispiel zu der Harmonie des wahren Künstlertums".
H.L., op. cit., p. 114.

again, the title indicates the unusual nature of the subject
and his life. In this instance, however, the artist is not a
martyr to enthusiasm for art, but the victim of his own
troubled disposition.

Nevertheless, the Klosterbruder introduces his tale
with a seemingly auspicious motif. He is moved by the
example of Cosimo to picture Nature as an eternally
industrious worker who mixes the ingredients of life
playfully and heedlessly. Such random blending, however, is
inherently ambivalent. Each creature is abandoned to its
torment or pleasure. Occasionally Nature produces those
strange beings at whom the world may only stare in open
amazement. These phenomena, although wonderful in their way,
may also prove to be unbalanced and problematical.

This appears indeed to be the case with Cosimo, whom
Nature had given an effervescent imagination and a dark,
melancholy spirit:

> Die Natur hatte sein Inneres mit einer immer
> gärenden Phantasie erfüllt, und seinen Geist mit
> schweren und düstern Gewitterwolken bezogen, so dass
> sein Gemüt immer in unruhiger Arbeit war, und unter
> ausschweifenden Bildern umhertrieb, ohne jemals sich
> in einfacher und heiterer Schönheit zu spiegeln.
> (pp. 72-73)

This aggregate of negative qualities evidently precludes
harmonious self-expression. Already in his youth, Cosimo is
set apart from his fellows by his restless imagination. He

is never able to concentrate on one thing alone and his
outlandish daydreams cause him to lose contact with reality:

> ... immer zog ein Schwarm von fremden, seltsamen
> Ideen durch sein Gehirn und entrückte ihn aus der
> Gegenwart. (p. 73)

Another anti-social tendency may be seen in the repugnance
which he feels for the company of men. He prefers to live in
dismal solitude where he can best devote himself to his wild
fantasies. He remains in a locked room, far from the
unwanted interference of society.

Cosimo's preferences and dislikes follow a perverse
logic of their own: he takes great delight in sudden bursts
of rain, yet cowers like a child when there is a
thunderstorm. He does not suffer his room to be cleaned or
his garden to be tended. Instead, he likes to see untamed
Nature all around him. He takes pleasure in all that is
repulsive to others, particularly in malformations such as
monstrous plants and creatures. His bizarre taste reflects
itself in his paintings, which generally portray wild
bacchanalia, orgies and terrifying monsters.

A particularly good opportunity for Cosimo to express
his fantasies is provided by the wild atmosphere of
carnival. On one occasion, he arranges in secret a chilling
spectacle which appears to be diametrically opposed to the
light-heartedness and festive spirit of the other
masquerades and pageants. Upon a huge black wagon drawn by
four black oxen, the triumphant figure of death parades his

scythe. To the eerie sound of horns, the dead rise from
their coffins to sing of the terrors of death and remind the
awe-stricken onlookers of their mortal condition.

Despite the initial shock it creates, this macabre
extravaganza is greeted enthusiastically. Indeed, as the
Klosterbruder explains, Cosimo appears to exert a strange
power over his audience:

> Daneben möcht ich auch noch sagen, dass solchen
> ausgezeichneten Geistern, wie dieser Piero di Cosimo
> war, vom Himmel eine geheime Gewalt eingepflanzt zu
> sein scheinet, durch die fremden und
> ausserordentlichen Dinge, welche sie tun, die Köpfe,
> auch des gemeinen Haufens, einzunehmen. (p. 76)

Even the wayward Cosimo is party to a divine gift of sorts,
which enables him to captivate others. Even though his
procession cannot be regarded as artistic in the strictest
sense, it does reveal the flame of his creative genius and
his latent ability to communicate.[44]

Other potentially positive qualities are shared by
Cosimo with Michelangelo and Leonardo. They are all
imaginative, industrious artists and keen observers. The
links between Cosimo and Leonardo are recognized in the
Klosterbruder's qualified comparison of their natures:

> ... denn beide wurden von einem immer lebendigen,
> vielsinnigen Geiste umhergetrieben — jener aber in
> finstere Wolkenregionen der Luft —, dieser unter die

[44] See Rose Kahnt, op. cit., p. 86.

ganze wirkliche Natur und unter das ganze Gewimmel

der Erde. (p. 78)

This distinction is best revealed in two parallel passages
which describe how the artists observe Nature, and the
stimulus this provides.[45] Of Cosimo, it is said:

Oft auch heftete er seine Augen starr auf alte

befleckte, buntfärbige Mauern, oder auf die Wolken

am Himmel, und seine Einbildung ergriff aus allen

solchen Spielen der Natur mancherlei abenteuerliche

Ideen zu wilden Schlachten mit Pferden oder zu

grossen Gebirgslandschaften mit fremdartigen

Städten. (p. 74)

Similarly, it is reported of Leonardo:

Auch betrachtete er, ..., oft lange und ganz in sich

verloren, altes Gemäuer, worauf die Zeit mit

allerlei Figuren und Farben gespielt hatte, oder

vielfarbige Steine mit irgend seltsamen Zeichnungen.

Daraus sprang ihm dann, während des unverrückten

Anschauens, manche schöne Idee von Landschaften oder

Schlachtgewimmel oder fremden Stellungen und

Gesichtern hervor. (p. 39)

The only essential difference is that Cosimo's ideas are
"abenteuerlich" whereas those of Leonardo are "schön". A
closer resemblance may be observed in the love of the
unusual which Cosimo shares both with Leonardo and

[45]The similarity of these two passages has already been
indicated by Marianne Frey, op. cit., p. 6.

Michelangelo. Such parallels to these great artists do not
vindicate Cosimo, nor do they necessarily cast doubt on the
former. They do indicate, however, that the distinctions
between the great Renaissance artists and their problematic
counterparts are not always clearly defined.

Nevertheless, Cosimo is essentially a figure of
questionable merit as an artist and as an individual. Unlike
Leonardo, he does not mellow with age, but undergoes a
marked deterioration. As he appproaches his eightieth year,
he is pursued by ever wilder fantasies. To these tortures of
the mind are added the physical afflictions of old age.
Typically, despite great suffering, he spurns all offers of
help. His behaviour and aversions become more irrational
than ever before. No longer able to guide the brush with his
trembling, crippled hands, he attempts to do them violence.
He takes an uncommon interest in his own misery. He talks
much of the horror of being consumed by a slow creeping
illness, having to make one's will and being surrounded by
weeping relatives instead of being called to the Last
Judgement in a single stroke of time. These dismal thoughts
remain with him constantly until the end. His fate is as
tragic as that of Francia.

The sum of Cosimo's sombre, almost daemonic qualities
leads the Klosterbruder to exclude him from the ranks of
genuine artists:

... so kann ich nicht glauben, dass dieser Piero di
Cosimo ein wahrhaft-echter Künstlergeist gewesen
ist. (p. 78)

His rationale for this judgement explains that the artist
should be a useful instrument ("Werkzeug") that is capable
of reflecting the whole of Nature in a beautiful fashion.
His metaphor of the raging sea and the clear river expresses
aptly the difference between the wild spirit of one such as
Cosimo and the calm nature of one such as Raphael:[46]

In dem tobenden und schäumenden Meere spiegelt sich
der Himmel nicht; — der klare Fluss ist es, worin
Bäume und Felsen und alle Gestirne des Firmamentes
sich wohlgefällig beschauen. (p. 78)

The Klosterbruder sees him not as an artist, but as a kind
of work of art — a chance product of Creation.

3.3.3 Antonio

The two letter-episodes which focus on the figure of
the fictitious young Renaissance artist Antonio are
thematically related to the artist vitae in that they too
illuminate a particular aspect of the artistic spirit.

Antonio is representative of the quasi-artist or
artiste manqué, whose aspirations fall short of their
achievement. In his case, it appears that his disposition is
to blame rather than technical ineptitude:

[46]Cf. Mary Schubert, op. cit., p. 114.

> Aber bei aller Stetigkeit seines Eifers und seiner
> recht eisernen Begier, irgend etwas Vortreffliches
> hervorzubringen, besass er zugleich eine gewisse
> Blödigkeit und Eingeschränktheit des Geistes, bei
> welcher die Pflanze der Kunst immer einen
> unterdrückten und gebrechlichen Wuchs behält, und
> nie frei und gesund zum Himmel emporschiessen kann:
> eine unglückliche Konstellation der Gemütskräfte,
> welche schon manche Halbkünstler auf die Welt
> gesetzt hat. (p. 25)

Moreover, it appears that Antonio does not possess the
imagination and taste necessary in the conception and
execution of works of art. His lack of inspiration and
originality restrict his development. He must remain an
imitator and an admirer of genuine artists.

The second pair of letters reveals that Antonio is too
introspective and too worldly for his profession. He lacks
the receptiveness of the true artist and does not seem to
make a distinction between worldly love and spiritual love.
He seeks inspiration actively in the earthly sphere instead
of allowing it to come from above.[47] He is more suited to
the appreciation of art than to its practice. [48]

[47]Cf. Heinz Lippuner, op. cit., p. 134.
[48]Compare the words of the Klosterbruder concerning
Berglinger's suitability as an artist (p. 131).

3.4 The "Malerchronik"

As already indicated, this section of the
Herzensergiessungen presents the whole spectrum of artistic
genius within the golden past and serves as a summary of the
previous episodes of the work. In addition to artists of the
Italian Renaissance, it includes some from later periods,
such as the French painter and engraver Jacques Callot.[49]

Of the artists already considered by the Klosterbruder,
only Raphael reappears here. Once again, he takes first
position in a series of character studies which reveal the
power and manifold effect of artistic genius. Three new and
significant facts concerning his life emerge. He enjoyed an
idyllic family life as a child. His whole life is a model of
peace and serenity: "einfach, sanft und heiter wie ein
fliessender Bach" (p. 101). Moreover, his Christlike
charisma enables him to create an atmosphere of harmony
amongst his many students and followers. These points,
however, are nothing more than variations on a well
established theme. The image of Raphael remains unchanged.
It would seem, therefore, that the purpose of this portrait
is to restate the ideal, thus providing the same perspective
for this individual section as for the whole work.

With one notable exception (Spinello), the remaining
artists appear in random order or as part of a group.
Immediately following Raphael on the Klosterbruder's scale

[49] The individual artists of the "Malerchronik" have
generally been ignored by critics. Heinz Lippuner lists and
characterizes some of their number, op. cit., pp. 55-56.

of excellence is Fra Angelico da Fiesole. He embodies the
ideal by virtue of his twofold calling as a friar and
artist. Thus, he provides something of a parallel to the
Klosterbruder himself. Indeed, they share the same belief in
the essential unity of art and religion. Fra Angelico
regards painting as an act of atonement, "eine heilige
Bussübung", which is to be preceded by prayer. Like Raphael,
he paints according to an image received from heaven: "wie
der Himmel es ihm eingegeben hatte" (p. 109). Moreover, he
too is a model of Christian values. He is a modest man who
prefers a quiet, simple life of piety to the Pope's offer of
a bishop's mitre.

Perhaps next in line after Fra Angelico is Lippo
Dalmasio, who, like Raphael, is renowned for his wonderful
paintings of the Madonna. Annibale Caracci and Parmeggiano
provide further examples of great enthusiasm for art.
Giotto, Domenico Beccafuni, Contucci, Polidoro da Caravaggio
and Callot are artists whose special love for art goes back
to their earliest childhood. Domenichino, however, appears
to be another example of the ambivalent artist: "ein
merkwürdiges Beispiel von einem heissen Eifer in der Kunst"
(p. 103). Like the great artists of his era, he is an
extremely zealous and skillful painter, yet he becomes so
involved in his art that he acts out the emotions of his
subjects in a disturbing manner. More questionable still is
the figure of Mario Albertinelli. As a painter he is as
industrious as any other, yet as a man he is given to

restlessness and worldly pleasures. Tired of the wearisome
technical aspects of painting, he decides to lead the
carefree life of an innkeeper, but returns eventually to his
original calling.

The series ends with a "recht seltsamen Geschichte"
which concerns an artist called Spinello. His story serves
as a counterbalance to that of Raphael at the beginning of
this section. We are told how he portrays the fall of the
wicked angels. He depicts the archangel Michael fighting a
seven-headed dragon, below them is Lucifer in the form of a
terrifying monster — a scene which might appeal equally to
the taste of Cosimo, Leonardo, or even Michelangelo.
Moreover, like Cosimo, he is easily carried away by his
imagination. He becomes possessed by his own figure of the
devil, which comes to berate him in a dream — a stark
contrast to the dream sequence in "Raffaels Erscheinung".
Spinello's tragic fate, however, is similar to that of
Francia in that he too experiences a devastating shock to
his sanity. As a direct consequence of the terrifying
apparition which haunts him, he becomes deranged and dies
soon thereafter.

3.5 Conclusions

A close, textually conscious study of the vitae of the
Renaissance artists and thematically related sections of the
Herzensergiessungen reveals that the "golden past" is

substantially more complex and somewhat less idyllic than
one might assume from the body of Wackenroder criticism. It
is important here to distinguish between the Klosterbruder's
enthusiastic presentation of the past and the reality which
emerges from his accounts. It should be noted that he
generally emphasizes the positive qualities of any
particular artist and minimizes the significance of negative
ones. This is especially noticeable in the vitae of
Francesco Francia and Leonardo da Vinci.

Admittedly, there are many aspects of the past which
provide a marked contrast to the modern reality of
Berglinger's age. The Renaissance appears as an era of
extraordinary enthusiasm for art and almost unparallelled
artistic achievement, in which the artist enjoys universal
approbation and respect. Individual artists of this period
transcend the limitations of lesser men to become Romantic
artists in the true sense of the term as defined by
Friedrich Schlegel. They are priests as well as artists
since they are able to translate a divinely inspired image
into a beautiful work of art, thereby presenting it to man
in a form which he is capable of understanding. Some of
them, particularly Raphael, Dürer and Michelangelo, extend
the spiritual role of the artist by serving as models of
Christian piety and moral living. The Renaissance artist may
also be a teacher (as the founder of his own school) and a
scientist (Leonardo da Vinci, Michelangelo).

In addition to such positive aspects, however, a
significant number of negative ones are also revealed in the
vitae of certain artists. Indeed, there are very few,
perhaps only Raphael, Dürer and Fra Giovanni Angelico da
Fiesole of the "Malerchronik", who appear to be beyond
reproach. These ideal artists are juxtaposed with others of
an ambivalent, problematic, or even suspect nature. The
genius of art seems itself to be an ambivalent force in that
it drives the artist in the direction of his natural
tendencies, regardless of whether these are of a positive or
negative nature. If the artist is of a calm, perfectly
balanced disposition, such as is the case with Raphael, the
creative force within him will reflect itself in beauty and
harmony. Conversely, if the artist is of a disturbed, unruly
nature, as is true of Cosimo, the results may be bizarre and
outlandish. Between these two extremes lie the myriad
possibilities of the artist's "Konstellation der
Gemütskräfte" (p. 25). It remains to be seen where the
figure of Berglinger may be placed within the range of
possibilities.

4. The modern problematic artist: Joseph Berglinger in perspective

Having turned his eyes repeatedly to the past in search
of spiritual comfort within the world of Renaissance art,
the Klosterbruder is now driven from within to recount the
story of an artist of modern times, that of his dearest
friend, the composer Joseph Berglinger. Although the
disquieting title of the Berglinger-story, "Das merkwürdige
musikalische Leben des Tonkünstlers Joseph Berglinger",
echoes that which heralds the vita of the problematic
Renaissance artist Francesco Francia, the Klosterbruder's
words suggest that there is also a positive aspect: [50]

Aber ich will mich daran laben, der Geschichte

deines Geistes ... in meinen Gedanken nachzugehen

und denen, die Freude daran haben, deine Geschichte

erzählen. (p. 111)

These are the first of a whole medley of positive and
negative signals, similar to those already observed in the
vitae of Renaissance artists, which are to be found
throughout the Berglinger-story. They are indicative of the
complex duality which Berglinger embodies. The following
interpretation of his life-story will serve as the basis of
a subsequent comparison of Berglinger to the other artist

[50] This similarity of the two titles is noted by Elmar
Hertrich, op. cit., p. 23.

figures of the *Herzensergiessungen*, which will allow him to
be seen in a true perspective.

4.1 Joseph Berglinger: The story of his spirit

As already noted, the Berglinger-story is divided into
two parts ("Hauptstücke"). In addition, each part appears to
fall thematically into three sections which correspond to
significant episodes or stages in Berglinger's life.[51]

Part one, which covers an unspecified period from the
time of his birth to early adolescence, begins with an
account of his family circumstances in which we are given a
substantial portrait of his father and an initial glimpse of
his own inner world of fantasy and music. The middle section
focuses on a determining childhood experience: his exposure
to (church) music during a visit to the city of the
episcopal residence. The final section traces the growing
conflict between Berglinger and his father, itself part of a
broader struggle between his imaginative nature and the
trammels of earthly existence. In the end he runs away from
home back to the city and its promise of musical
fulfillment.

Part two, the story of Berglinger's life as a composer,
refers only briefly to the intervening years of his musical
training. Although he has attained the coveted position of

[51]Cf. Elmar Hertrich, op. cit., p. 23. The "gewisse
Entsprechung" which he finds between the sections of the
first and second parts appears somewhat strained.

Kapellmeister, he finds himself at odds with the demands of
society. In the first section the frustration of his
youthful enthusiasm is reflected in a letter to the
Klosterbruder, whose own words supplement the picture of his
friend's despondency. The middle section describes the
circumstances surrounding Berglinger's return home to his
father's deathbed. The final section deals with his last
composition and his own, untimely death. The Klosterbruder
concludes his account (and the work) by elaborating on the
source of Berglinger's lifelong dilemma, and by posing
several questions regarding the nature of the genuine
artist.

4.1.1 "Erstes Hauptstück"

The initial setting for the story is the little town in
southern Germany where Berglinger was born. His mother died
giving birth to him, and his father, a penniless and already
somewhat elderly doctor, is barely able to support himself
and the six children.

The account of Berglinger's bleak family circumstances
proceeds by way of a distinctly two-sided character study of
his father into which is woven a contradistinctive portrait
of Joseph himself.[52] Initially at least, the father appears
in a positive light. We learn that he was originally a
compassionate man who delighted in helping his fellows as

[52]With Elmar Hertrich I observe certain points of similarity
within this contrast. E.H., op. cit., p. 27.

much as his meagre resources would allow. His charitable
acts were the source of spiritual nourishment for his pious
soul which thrived on sentimental emotions.

Joseph, however, does not share his father's
disposition. From the very beginning he is not one to be
satisfied with a commonplace existence and the performance
of good deeds, but wishes to strive for higher things by
reaching up exultantly towards heaven:

— aber ihn hatte der Himmel nun einmal so
eingerichtet, dass er immer nach etwas Höherem
trachtete; es genügte ihm nicht die blosse
Gesundheit der Seele und dass sie ihre ordentlichen
Geschäfte auf Erden, als arbeiten und Gutes tun,
verrichtete; — er wollte, dass sie auch in üppigem
Übermute dahertanzen und zum Himmel, als zu ihrem
Ursprunge, hinaufjauchzen sollte. (p. 112)

This first glimpse of Berglinger's spirit provides a clear
indication of the potential conflict between his ethereal
enthusiasm and prosaic reality, and reveals his natural
propensity for self-centredness and introspection. We may
note here the careful prefiguration of one aspect of
Berglinger's nature in the previous portrait of his father.
The latter's sentimental inwardness has its counterpart in
the introspectiveness of his son.[53]

The figure of the father, however, like that of
Berglinger himself, is one of considerable complexity. As

[53]Cf. Elmar Hertrich, op. cit., p. 27.

the narrative turns to focus on him again, a new and
disquieting side of his personality is revealed. As a
doctor, he had always been involved in the study of ailments
and the mysteries of the human body. His delight in the
pursuit of such knowledge, however, appears somewhat
unnatural. In the course of time his fascination with
disease had become an insidious poison, which, together with
the increasing burdens of poverty and old age, had begun to
eat away at the original goodness of his heart. [54]

Once again, notwithstanding the overriding
contrarieties which separate them, there is a striking
parallel to be observed here between the father's obsession
with the disorders of the flesh and Berglinger's
intoxication with fantasy and music. Significantly, the
father's all-consuming interest is mundane, whereas that of
his son is ethereal, yet the effects are the same: both
Berglingers undergo an inner transformation and are rendered
insensitive, albeit in different ways, to the cares of
others. [55] In the case of Joseph, an initial indication of
this can be seen in his differentiated attitude towards
himself and the other members of his family:

> Seinen Vater und seine Geschwister liebte er
>
> aufrichtig; aber sein Inneres schätzte er über alles
>
> und hielt es vor andern heimlich und verborgen. (p.

[54] There is no textual support for Mary Schubert's claim that
"his greatest joy had always been in helping, giving
counsel, and alms; hence his inability to do so caused him
much unhappiness". M. S., op. cit., p. 127.
[55] Cf. Elmar Hertrich, op. cit., p. 27.

113)

The technique of contradistinctive mirroring, which, as we
have seen, has succeeded in portraying father and son side
by side within a framework of contrasts and similarities, is
also visible in the contrastive picture of Berglinger and
his five sisters:

> Josephs Schwestern waren teils kränklich, teils von
> schwachem Geiste und führten ein kläglich einsames
> Leben in ihrer dunklen kleinen Stube. (p. 113)

Although he grows up under the same pitiful conditions,
Berglinger is gifted with a lively imagination, yet his
father interprets this as a sign that he too is
feebleminded:

> Er war stets einsam und still für sich und weidete
> sich nur an seinen inneren Phantasien; drum hielt
> der Vater auch ihn ein wenig verkehrt und blödes
> Geistes. (p. 113)

Notwithstanding such parallels or suggested similarities
between Berglinger and the other members of his family,
which may be inferred from the text, the Klosterbruder
declares that no one could be less suited to such
surroundings. He likens him to the good seed fallen on stony
ground:

> In diese Familie konnte niemand weniger passen als
> Joseph, der immer in schöner Einbildung und
> himmlischen Träumen lebte. Seine Seele glich einem
> zarten Bäumchen, dessen Samenkorn ein Vogel in das

> Gemäuer öder Ruinen fallen liess, wo es zwischen
> harten Steinen jungfräulich hervorschiesset. (p.
> 113)[56]

The isolating effect of such a background, however, is
compounded by Berglinger's natural tendency towards
inwardness. His love of music, which begins in earliest
childhood, leads him further in this direction. From the
very beginning, there is a suggestion that its influence on
him will not be entirely beneficial:

> Er hörte zuweilen jemanden auf dem Klaviere spielen
> und spielte auch selber etwas. Nach und nach bildete
> er sich durch den oft wiederholten Genuss auf eine
> so eigene Weise aus, dass sein Inneres ganz und gar
> zu Musik ward und sein Gemüt, von dieser Kunst
> gelockt, immer in den dämmernden Irrgängen
> poetischer Empfindung umherschweifte. (p. 113)

The full effect of music on his soul is described in the
section dealing with his visit to the episcopal residence,
where, for a few short weeks, he lives "as if truly in
heaven".

It is here that he first experiences the exalting power
of music in its grandest form. Significantly, it is the
music of the churches which draws him most. The religious
oratorios, cantilenas and chorales which he hears intensify
his feelings of devotion:

[56] This is the first of numerous biblical and religious
motifs which, either directly or implicitly, link Berglinger
and his music to religion.

Vornehmlich besuchte er die Kirchen und hörte die
heiligen Oratorien, Kantilenen und Chöre ... wobei
er oft, aus innerer Andacht, demütig auf den Knieen
lag. (p. 114)

Above all, the music provides him with a sense of spiritual
purification, since it frees him from the mundane world
which surrounds him. If we examine his emotions before the
music commences, we find him to be disturbed by the presence
of those around him and the noise of their bustling und
murmuring:

Ehe die Musik anbrach, war es ihm, wenn er so in dem
gedrängten, leise murmelnden Gewimmel der Volksmenge
stand, als wenn er das gewöhnliche und gemeine Leben
der Menschen als einen grossen Jahrmarkt unmelodisch
... summen hörte; sein Kopf ward von leeren,
irdischen Kleinigkeiten betäubt. (p. 114)

As soon as the music begins, however, he feels himself to be
raised up from the mortal world of men into the heavens:

Da war es ihm, als wenn auf einmal seiner Seele
grosse Flügel ausgespannt, als wenn er von einer
dürren Heide aufgehoben würde, der trübe
Wolkenvorhang vor den sterblichen Augen verschwände
und er zum lichten Himmel emporschwebte. (p. 114)

His soul is cleansed of earthly things:

sein Inneres war von allen irdischen Kleinigkeiten,
welche der wahre Staub auf dem Glanze der Seele
sind, gereinigt ... (p. 114)

It is interesting to note here that the stimulus of music, in addition to releasing a variety of emotions from his heart, evokes images in his mind.[57] More significant, however, is the fact that it causes him to withdraw even further into his private realm of the spirit.[58] Its effect on him is dehumanizing in as far as the elation which it produces is mingled with feelings of transcendence and superiority. Thus the spiritual illumination which fills his soul at certain stages in the music leads him to feel himself to be above the ordinary world:

> Ja bei manchen Stellen der Musik endlich schien ein
> besonderer Lichtstrahl in seine Seele zu fallen; es
> war ihm, als wenn er dabei auf einmal weit klüger
> würde, und mit helleren Augen und einer gewissen
> erhabenen und ruhigen Wehmut, auf die ganze
> wimmelnde Welt herabsähe. (p. 115)

As the music ends, however, he finds himself dragged down into prosaic reality. The banality of everyday life is so repulsive to him that he decides to spend all his days revelling in the beautiful world of music:

> Er dachte: du musst zeitlebens, ohne Aufhören, in
> diesem schönen poetischen Taumel bleiben, und dein
> ganzes Leben muss eine Musik sein. (p. 115)

The Klosterbruder's words confirm our suspicions regarding one prime cause of Berglinger's vicissitudes:

[57] As is well known, synaesthetic imagery is a common feature of Romantic literature.
[58] Cf. Mary Schubert, op. cit., pp. 130-31.

Diese bittere Misshelligkeit zwischen seinem
angebornen ätherischen Enthusiasmus und dem
irdischen Anteil an dem Leben eines jeden Menschen,
der jeden täglich aus seinen Schwärmereien mit
Gewalt herabziehet, quälte ihn sein ganzes Leben
hindurch. — (p. 115)

Whereas it becomes evident that Berglinger's problems
are due, in part, to the prevailing attitude towards art, it
is equally clear that his situation is complicated by this
inherent dilemma. Thus, it is not enough to label him simply
as a problematic artist per se, rather, it is essential to
weigh factors of social constraint against the intrinsic
problems generated by the imbalance in his disposition in
order to arrive at a valid appraisal of this Romantic artist
within the context of his environment. The interplay of
external and internal, social and dispositional factors
becomes increasingly significant as the story progresses.
Berglinger's musical experiences in the city serve to
intensify the growing struggle within him. He is
disconsolate at the necessity of returning home to a family
that is bound only by the physical necessities of life and
which has no understanding for his spiritual needs.

Wie traurig und niedergedrückt fühlte er sich wieder
in einer Familie, deren ganzes Leben und Weben nur
um die kümmerliche Befriedigung der notwendigsten
physischen Bedürfnisse drehte, und bei einem Vater,
der so wenig in seine Neigungen einstimmte. (p. 117)

His father regards music as nothing better than a handmaiden
of sensuality and as a plaything of the rich. He had always
regarded his son's love for it with displeasure, but now
that its "pernicious" influence over him has become
excessive in his eyes, he makes a determined effort to
reform him. Naturally enough, he tries to convert him to his
own calling of medicine, which he considers to be the most
beneficial servant of mankind. The physical nature of this
profession and the necessary contact with people which it
involves, however, make it unacceptable to Berglinger. He is
far too detached from life and views his fellows with
indifference, although we may note that he is later
tormented with guilt in this regard. His insensitivity to
others remains throughout a major obstacle which restricts
his development as a genuine artist within the
Klosterbruder's frame of reference.

Not surprisingly, the father's decision to curb his
son's ways does nothing to resolve their conflict of
interests and only precipitates the inevitable crisis.
Berglinger's attempt to satisfy his father's wishes by
studying medicine is futile since it only aggravates the
spiritual struggle within him. Unable to repress his ever
growing love for music, he runs off to neighbouring towns
whenever there is a performance to be heard. He recalls
constantly the wonderful days which he had spent in the
city. It is significant that he thinks, in particular, of
the holy oratorio which had made such an indelible

impression on his memory:

 Stabat Mater dolorosa

 Iuxta crucem lacrymosa

 Dum pendebat filius:

 Cuius animam gementem,

 Contristantem et dolentem

 Pertransivit gladius. (p. 118)

The motif of Christ's lustrous spirit being transfixed by an
all too earthly instrument, the sword, provides an
unmistakable parallel to Berglinger's own situation.[59] His
ethereal nature is made to suffer in a world that is
governed by harsh physical realities and the banal. Thus his
heavenly dreams and his musical enjoyment are repeatedly
disturbed by the squabbling of his sisters, his father's
impecuniosity and the misery of those seeking charity. His
feelings, though understandable given his disposition, are
not entirely commendable.

 There is no doubt, however, that he realizes this
himself and experiences some remorse. He wonders that the
world is as it is, that he is forced to live in the press of
the crowd and take part in the general misery. On the other
hand, it seems to him that there is justification in his
father's belief that it is the duty and destiny of every man
to care for those less fortunate than himself. Inside him,
however, there is a voice which tells him that he was born

[59]The passion-motif and other Christ-Berglinger parallels
are a significant aspect of the Berglinger-story.

for higher things. At this early age he senses the
possibility of becoming an artistic intermediary and prays
to God that he may become an excellent artist in the eyes of
heaven and mankind. He feels that he has been cast into such
miserable surroundings so that his rise to glory might be
all the more splendid. It is in this ecstatic frame of mind
that he composes a number of poems which he then sets to
music. The example given, his prayer to St. Cecilia, of
which the last stanza may stand here for the whole, reveals
how self-centred his desire is to become a musician:

Öffne mir der Menschen Geister,

Dass ich ihrer Seelen Meister

Durch die Kraft der Töne sei;

Dass mein Geist die Welt durchklinge,

Sympathetisch sie durchdringe,

Sie berausch' in Phantasei! — (p. 121)

What is particularly noticeable throughout the prayer is the
recurrence of first person singular pronouns and
possessives.[60] These attest to the emphasis which he places
on self-realization through music. His desire to be an
intermediary is clouded by egocentricity[61]

For more than a year Berglinger torments himself and
broods over the possibility of leaving home in order to
study music in the city. His relationship to his father has

[60] ich — mich — ich — mir — ich — mein — mich — mein — meinen
— mein — ich — mir — ich — mein.
[61] In contrast, Novalis' artist figures are much less
self-centred.

deteriorated to the extent that the latter no longer takes
any interest in him and abandons his attempt to instil
interest in medicine in him.

At this point the boy reaches a spiritual nadir and is
unable to emerge from the abyss of doubt in which he finds
himself. Significantly, it is the figure of Christ to which
he turns for guidance:

Gottes Sohn! um deiner Wunden willen,

Kannst du nicht die Angst des Herzens stillen?

Kannst du mir nicht Offenbarung schenken,

Was ich innerlich soll wohl bedenken?

Kannst du mir die rechte Bahn nicht zeigen?

Nicht mein Herz zum rechten Wege neigen? (p. 122)

Berglinger appears to identify himself in some way with the
figure of Christ. Indeed, like Jesus, he suffers in this
world because of his devotion to the spiritual realm. Joseph
feels that he is an innocent victim of circumstance:

Ach, was muss ich ohne mein Verschulden

Für Versuchung und für Marter dulden! (p. 122)

The Jesus-parallel, however, may not be taken too far. The
similarity serves only to highlight Berglinger's dilemma,
and not to endow him with an aura of saintliness. Be that as
it may, it is not a heavenly sign but a particularly
vehement outburst of anger against him on the part of his
father during a family quarrel which drives all doubts and

considerations from his mind.[62] He resolves to leave home as
soon as the Easter festival is over.[63] No longer able to
resist the tempting world of music, he sets out for the
city:

> — er kam immer näher — und endlich, — gütiger
> Himmel! welch Entzücken! endlich sah er die Türme
> der herrlichen Stadt vor sich liegen. (p. 123)

4.1.2 "Zweites Hauptstück"

The Klosterbruder's account of Berglinger's life
continues from a point in time several years after his
flight to the city.[64] Although Berglinger's musical
aspirations have met with considerable success, there
appears to be a distinct discrepancy between this outward
achievement and the inner destruction which accompanies
it.[65] Having studied his art diligently, he has now attained
as much as he could ever have hoped for by becoming
Kapellmeister. The splendour in which he lives, however, can
in no way compensate for the spiritual tribulations which he
is forced to endure. This is attested to in a letter which
he writes to the Klosterbruder two years or so later.[66]

[62]Typically, it is something especially banal which causes
such a strong reaction in Joseph.
[63]Yet another sounding of the passion motif.
[64]This time lapse brings out effectively the contrast
between Berglinger's joyful anticipation at the end of part
one and his despair in part two. See Elmar Hertrich, op.
cit., p. 51.
[65]ibid.
[66]For a structural analysis of the letter see Elmar
Hertrich, op. cit., p. 55.

The first lines reveal that it is the trauma of disillusionment of his earlier enthusiasm and idealism with which he has to contend. He contrasts his present misery with the wonderful dreams of his youth. The glorious future which he had looked forward to has turned into a pitiable reality. This drastic change had begun with the realization that music was based on rigid principles which had to be learned and put into practice before one was allowed simply to express one's feelings with it:

> Wie ich mich quälen musste, erst mit dem gemeinen
> wissenschaftlichen Maschinenverstande ein
> regelrechtes Ding herauszubringen, eh' ich dran
> denken konnte, mein Gefühl mit den Tönen zu
> handhaben! (p. 124)

These rules are far too rational and calculated for one such as Berglinger who seeks only to revel in a musical fantasy world. Thus he looks back longingly to the days of his childhood when he was filled with wonderment in the concert hall and hoped that in time people would come there to listen to his own works and offer up their feelings to him. To his chagrin, however, this ardent desire remains unfulfilled. Although he has indeed become a composer and audiences do gather to hear his music, it is a hollow reward. He has sadly deceived himself by thinking that those who attend do so out of reverence for music itself and for its creator:

> Dass ich mir einbilden konnte, diese in Gold und
> Seide stolzierende Zuhörerschaft käme zusammen, um
> ein Kunstwerk zu geniessen, um ihr Herz zu erwärmen,
> ihre Empfindung dem Künstler darzubringen! (pp.
> 124-25)

Up to this point Berglinger's difficulties would seem, by
and large, to have stemmed from two distinct sources: his
overly imaginative and introspective nature which rejects
all that belongs to the ordinary, worldly sphere in favour
of intoxicating flights into the ethereal realm, and the
misfortune of being born into a family which has so little
understanding for his musical inclinations. To these we may
now add a third, one already anticipated, that of society
itself. Not only does it appear that appreciation of the
musical art has been totally subjected to the occasion, i.e.
the pomp and glamour of a gathering of the upper echelons,
but, to Berglinger's deep personal despair, it seems that,
in the minds of all excepting himself, the musical
experience has been stripped completely of its spiritual
significance:

> Können doch diese Seelen selbst in dem
> majestätischen Dom, am heiligsten Feiertage, in dem
> alles Grosse und Schöne, was Kunst und Religion nur
> hat, mit Gewalt auf sie eindringt, können sie dann
> nicht einmal erhitzt werden, und sie sollten's im
> Konzertsaal? (p. 125)

This distinctive (early German) Romantic feature, the

conception of the essential unity of art and religion,
strongly represented throughout the *Herzensergiessungen*, is
central to our understanding of the modern dilemma as
experienced by the Klosterbruder and by Berglinger himself.
According to Berglinger, the very feeling and understanding
for music themselves have become unfashionable. Such is the
reality which confounds his boyhood dreams. Even where he
does find some semblance of heartfelt appreciation, it is
devalued by the rational, bookish manner in which it is
expressed. The only comfort that he can find is in the
notion that some kindred spirit may be able to draw the same
feeling from his works which he tried to put into them. Such
misgivings are clearly in harmony with the Klosterbruder's
comments regarding the demise of artistic appreciation.

Berglinger's censure of the prevailing modern attitude
towards art has three main points of attack. Firstly, as we
have already seen, he deplores the general absence of true
sensitivity for art itself and the rationalization of
feeling. Secondly, he condemns his fellow artists for their
notable lack of humility and their petty rivalry. He
complains that he is surrounded by artists who are filled
with self-importance as soon as their work has achieved
recognition and favour. This he regards as an arrogant
denial of their immense debt to God and Nature:

Lieber Himmel! sind wir denn nicht die Hälfte unsers
Verdienstes der Göttlichkeit der Kunst, der ewigen
Harmonie der Natur und die andere Hälfte dem

gültigen Schöpfer, der uns diesen Schatz anzuwenden
Fähigkeit gab, schuldig? (p. 126)

In stark contrast to his conceited confrères, Berglinger
views himself as nothing more than an imperfect medium; it
is art itself, not the artist, which should be the object of
our admiration:

Wahrhaftig, die Kunst ist es, was man verehren muss,
nicht den Künstler; — der ist nichts mehr als ein
schwaches Werkzeug. (p. 127)

His humility here, which may be contrasted with the
self-indulgence and somewhat vain attitude of his boyhood
years, points to a significant inner development in the
direction of the ideal. More importantly for the present
argument, it sets him distinctly apart from the other
artists of his era. In terms of his attitude towards art, he
appears as a spiritual descendant of the Renaissance (as
presented by the Klosterbruder), in which there was
universal deference to art as an expression of the divine
and of Nature.

The third of Berglinger's main objections concerns the
subjection of art to the whims of high-society. As we have
already seen, he is very critical of pomp and displays of
finery which go hand in hand with musical performances. In
addition, he resents the petty formalities of etiquette and,
in particular, the manner in which art is subordinated to
the will of the court. His reaction to the "impure
atmosphere" of cultured society is not uncharacteristic of a

certain strain of Romantic idealism. It is back to a world
uncomplicated by such impurities as pomp, decorum, rivalry
and artificially imposed restrictions on artistic expression
that he wishes to flee when he yearns:

> Ich möchte all diese Kultur im Stiche lassen und
>
> mich zu dem simplen Schweitzerhirten ins Gebirge
>
> hinflüchten und seine Alpenlieder, wonach er überall
>
> das Heimweh bekömmt, mit ihm spielen. (p. 127)[67]

Accompanying this desire is the realization that he had been
much happier in his childhood years, when he could simply
enjoy music instead of having to compose and perform it, as
he does now, under such adverse conditions.[68] Berglinger's
despair over the shattering of his childhood dreams finds
its most poignant expression in an emotionally charged
passage which re-sounds the now familiar motif of the
conflict between his ethereal nature and the mundane.
Although he once hoped to escape the trammels of earthly
existence on the wings of his spirit, he now concludes that
this is impossible. However hard he strives to raise himself
up above the ordinary world, he is still unable to free
himself from its relentless grasp:

[67]Elmar Hertrich notes an echoing here of Rousseau's protest
against the "kulturelle Verfeinerung des höfischen
Spätbarock". E. H., op. cit., p. 56.
[68]Cf. the Klosterbruder's comment: "Soll ich sagen, dass er
vielleicht mehr dazu geschaffen war, Kunst zu geniessen als
auszuüben?", p. 131.

> Ich gedachte in meiner Jugend dem irdischen Jammer
> zu entfliehen und bin nun erst recht in den Schlamm
> hineingeraten. Es ist wohl leider gewiss; man kann
> mit aller Anstrengung unsrer geistigen Fittiche der
> Erde nicht entkommen; sie zieht uns mit Gewalt
> zurück, und wir fallen wieder unter den gemeinsten
> Haufen der Menschen. (p. 126)

As the Klosterbruder explains in his commentary following
the letter, Berglinger felt lost and alone amidst the
clamour of so many discordant souls. Moreover, he feels that
his art is debased by the fact that it seems to make no
vivid impression on its audience. He falls into despair
because music, which has such a strange power over him, is
for others nothing more than a sensual stimulus or pleasant
pastime. He wonders whether it is not the most unfelicitous
notion to devote oneself totally to art, and delude oneself
as to the effect art has on the minds of men. He comes to
the conclusion that the artist might do better to strive for
the edification of his own self and that of a few kindred
spirits — a view which the Klosterbruder cannot totally
condemn. From Berglinger's letter and the comments of the
Klosterbruder it would appear that the Romantic artist in
the modern age is doomed to live in spiritual isolation from
the rest of society. Even if he endeavours to glorify God
and Nature by communicating his feelings through art, as
Berglinger evidently does, there is no-one capable of
understanding his message.

The remainder of Berglinger's troubled life is
summarized briefly. The Klosterbruder tells us that he lived
on as Kapellmeister for several years. He is burdened
continually by a growing sense of personal inadequacy or
artistic ineffectiveness. Notwithstanding his profound
artistic feeling and sensitivity, he comes to believe that
he is of little use to the world. [69] It is the numbing effect
of the attitude of society towards art, however, and not any
lack of talent or responsiveness on Berglinger's part, which
appears to be at the root of this particular dilemma. [70] As
he did in the letter to the Klosterbruder, he looks back
melancholically to the "pure, idealistic enthusiasm" of his
somewhat distant youth. Moreover, he recalls his father's
efforts to train him as a doctor, in order that he might
reduce the misery of mankind and thereby benefit the world.
At times he thinks that this course would have been better.
Beset by such thoughts, he becomes more and more despondent;
his very life is on the wane.

On one occasion, however, there is an uplifting, yet
painfully shattered respite in his creative life. He has
just directed a newly composed piece of his own in the

[69] Berglinger's despondency and his rejection of modern
society has often been viewed, particularly by more recent
criticism, as being "nihilistic". If one remembers, however,
that he remains within society, and that he makes a very
positive attempt to improve its sensitivity, then the misuse
of the term is all too evident.
[70] Altogether, the second "Hauptstück" seems to be more
sympathetic to Berglinger's position than the first, which
concentrates more on the inherently problematic side of his
nature as opposed to the failings of society.

concert hall. For the first time, it seems as if he achieves true success with his art over the hearts of all the listeners. The general wonderment and quiet, spellbound applause which he reaps convinces him that, for once at least, he has performed his art worthily. This encouragement spurs his desire to create music. Just as he is leaving the concert hall, however, he is accosted by a wretchedly clad girl whom he scarcely recognizes as his own youngest sister. The tragic news of his father's impending death brings him crashing down again into the harsh realities of the world:

> Da war wieder aller Gesang in seinem Busen
>
> zerrissen; in dumpfer Betäubung machte er sich
>
> fertig und reiste eilig nach seiner Vaterstadt. (p.
>
> 129)

Although Berglinger had always sent money to help support his needy family, he could never bring himself to visit his aged father. Notwithstanding the years of estrangement and their natural contrarieties, however, their last meeting is blessed with reconciliation and mutual understanding. Even so, Berglinger is mortified by the experience of his father's death. He finds that two of his sisters have gone astray; the eldest, to whom he sent the money, squandered most of it and allowed their father to waste away.[71]

[71]Elmar Hertrich sees a parallel here between Berglinger and his sisters which is not wholly convincing: "Und wenn seine Schwestern später noch tiefer in Elend sinken, so gelangt er zwar zu äusserlichem Glanz, beklagt aber, tief enttäuscht, sein 'elendes Leben'. Berglinger ist in Gefahr, dasselbe

[71] Filled with remorse, he provides for his sisters as best he can and returns to the city to attend to his affairs.

To the chagrin of his envious rivals, Berglinger has been chosen to compose a new Passion-piece for the forthcoming Easter festival. He finds himself in such a deep depression, however, that he is unable to rid himself of his earthly cares. Finally, he raises his hands imploringly towards heaven and fills his spirit with the "highest poetry" and "loud, exultant song". In a wonderful state of inspiration, he composes a Passion-piece encapsulating all the pain of suffering, which, as the Klosterbruder declares, will always remain a masterpiece.[72] The strain of this final, lasting achievement and the compounded effect of his worldly cares proves too much for him. After the performance he feels tired and weak. He is stricken with a debility of the nerves ("Nervenschwäche") and dies after a short illness, in the prime of life.

The major leitmotif of the Berglinger-story, Berglinger's inherent dilemma, is underpinned once more as the Klosterbruder goes on to pose the question:

Warum wollte der Himmel, dass sein ganzes Leben

hindurch der Kampf zwischen seinem ätherischen

Enthusiasmus und dem niedrigen Elend dieser Erde ihn

[71](cont'd)Schicksal zu erleiden, das zwei seiner Schwestern trifft, die nach ihm von zu Hause weglaufen." This seems somewhat overstressed. E. H., op. cit., p. 28.

[72]Mary Schubert mistranslates "Begeisterung" here as "enthusiasm", whereas it is implicit from the text that Berglinger has sought and indeed received some form of heavenly inspiration. M. S., op. cit., p. 301.

so unglücklich machen und endlich sein doppeltes

Wesen von Geist und Leib ganz voneinanderreissen

sollte! (p. 130)

He sees in Berglinger yet another example of the wonderful

variety of noble spirits which the heavens have placed in

the service of art. He recalls the examples of three

Renaissance artists — the modest Raphael, the unruly Guido

Reni and the upright Albrecht Dürer — all of whom, despite

their differing natures, produced works of spiritual

significance. The same may be said of Berglinger, albeit to

a lesser degree, who, in his own unique way, created music

of "such mysterious beauty".[73]

Before bringing his account to a close, the

Klosterbruder poses several questions concerning

Berglinger's nature and his suitability as an artist. He

laments the unsettling effect which his friend's exceptional

imaginative powers had over his creative life. This leads

him to ask whether Berglinger had not been created to

appreciate art, rather than to produce it. Indeed, it

appears that the question must be answered in the

affirmative. As Berglinger himself recognized, he was much

happier as a boy, when he could simply enjoy music, than as

a practicing musician. He even took a definite dislike to

the practical aspects of his craft. His creative life as a

[73]The relevant passage clearly indicates the authorial
intention of inviting a comparison between Berglinger and
the Renaissance artists of the earlier sections. I reserve
all further comment in this regard for the relevant sections
of the present chapter.

composer was fraught with dissatisfaction and unhappiness.
Yet it serves to remember that he was no mere failure, on
the contrary, he stands as a rare example of the true
artistic spirit in the modern age. Furthermore, as the
Klosterbruder previously stated, he is to be credited with
the existence of works, however few in number, which are of
undeniable beauty and lasting artistic value.

A further question asks whether the most fortunate
artists are not those in whom the power of art works quietly
and secretly in the form of a concealed genius, which leaves
their everyday lives undisturbed. This would also seem to
demand an affirmative response. Berglinger himself appears
to be a prime example of the artist whose unrestrained
enthusiasm and imagination render him unable to relate to
the world about him. This links up with the Klosterbruder's
next question. Now he asks whether the ever enthusiastic
artist should not also weave his "hohe Phantasien" firmly
into the fabric of earthly life, if he wishes to become a
"genuine" artist. Applied to Berglinger, this not only
points once again to the essential conflict which troubles
him throughout his lifetime, but also raises some doubt over
his standing as a genuine artist within the Klosterbruder's
frame of reference.

Nevertheless, the Klosterbruder does not exclude his
friend explicitly from the ranks of genuine artists, but
goes on to ask whether the power of creativity is not
something altogether more wondrous and, as he now senses,

more divine than the power of imagination ("Phantasie").[74]
Imagination then, like enthusiasm for art, is a necessary
part of the creative process, yet it is very much
subordinate to creative genius. Whereas imagination and
enthusiasm for art are prerequisite qualities of the artist,
he cannot become a **genuine** artist unless he is also endowed
with the god-given quality of the power of creativity.
Berglinger seeks heavenly inspiration on three occasions: in
his prayer to St. Cecilia, when he prays to Jesus for a
sign, and, finally, when he seeks inspiration whilst
composing his final work. It is only on this last occasion
that he appears indeed to be granted some form of heavenly
assistance:

> Er lag tief niedergedrückt und vergraben unter den
> Schlacken dieser Erde. Endlich riss er sich mit
> Gewalt auf und streckte mit dem heissesten Verlangen
> die Arme zum Himmel empor; er füllte seinen Geist
> mit der höchsten Poesie, mit lautem, jauchzendem
> Gesange an und schrieb in einer wunderbaren
> Begeisterung ... eine Passionsmusik nieder, die ...
> ewig ein Meisterstück bleiben wird. (p. 130)

For this one time at least, he too is party to divine
inspiration.

The Klosterbruder's final words, like his last three
questions, do not refer specifically to the example of Josef

[74]This is one of several instances where the Klosterbruder
appears to gain new insight.

Berglinger alone, but to all artists. He tells us that the
artistic spirit must remain an eternal secret, and, like
everything else that is great in this world, an object of
the highest admiration. After reminiscing on the life of his
friend, he can write no more, but concludes his work with
the hope that it may serve to arouse good thoughts in the
heart of one person or another. Thus, he closes the work on
a note of reserved optimism. Clearly the story of his
friend's life, like the vitae of the Renaissance artists,
has provided him with some consolation.

This may serve to remind us that the life of Joseph
Berglinger is intended to be seen in context. It is not
enough to produce an exegetic analysis of the
Berglinger-story alone; it is essential to compare his
example to those of the other artist figures of the
Herzensergiessungen, in order to relativize his merits and
failings. With this in mind I turn now to the other modern
artists as they appear in the work, especially the figure of
his friend the Klosterbruder, before reviewing the story of
Berglinger's spirit in the light of the Renaissance artists
already discussed.

4.2 Berglinger in a modern perspective

In his preface to the reader, the Klosterbruder
distances himself from the modern philosophy at the very
outset by stating that the essays which follow do not

conform to the tone of his age:

 Sie sind nicht im Ton der heutigen Welt abgefasst

 ... (p. 9)

As already noted, the Klosterbruder's comments in the
preface and, in particular, in the introduction to the
section on Francesco Francia indicate that the former
enthusiasm and universal respect for art now linger on only
in the hearts of a very few kindred souls. Towards the end
of the preface, he remarks that his essays are intended only
for the eyes of young artists and enthusiasts, who still
bear holy reverence ("heilige Ehrfurcht") in their hearts
for times gone by.

 In the modern age, the former spirit has been
superceded by a distinctly rationalized, more critical
approach to art. This new philosophy of art is epitomized,
in the eyes of the Klosterbruder, in the writings of one H.
von Ramdohr.[75] The express desire of the Klosterbruder
himself, as he indicates in the introduction to "Raffaels
Erscheinung", is to redress such views, which he considers
to be quasi-heretical, since they deny the divine element in
art. In the modern era, there are very few who are capable
of appreciating the essential unity of art and religion.

 Thus, the Klosterbruder and indeed Berglinger are to be
considered as rare examples of artistic natures, in whom the
spirit of the Renaissance and former times lives on. However

[75] Goethe, amongst other important literary figures of the
age, also objected strongly to (Friedrich von) Ramdohr's
views on art. See Mary Schubert, op. cit., p. 379.

problematic they may appear, however isolated, the authorial
intention is clearly that they be regarded by the reader as
being spiritually superior to their contemporaries. Indeed,
their personal dilemma, particularly in the case of the
Klosterbruder, may be attributed largely to the alienating
effect of the modern attitude towards art. In the case of
Berglinger, it appears that this dilemma is complicated by
dispositional factors.

These two inheritors of the aesthetico-spiritual legacy
from the past stand in stark contrast even to co-aeval
artists and enthusiasts. The modern artists, Berglinger's
confrères, whom we see through his eyes and those of the
Klosterbruder, are exposed as despicably shallow and pettily
rivalrous glory-seekers who have no sense of the true
majesty of art.[76] In the "Malerchronik", the Italian father
deplores the tendency amongst modern painters to fill their
works with vain displays of colour, whereas the Renaissance
greats had made their art a true servant of religion.
Berglinger's music, it should be noted, is completely
church-oriented. The modern enthusiast, as encountered by
Berglinger, is unable to express his artistic feelings
without resorting to the modern tendency of rationalization.
Seen in this context, both the Klosterbruder **and** Berglinger
appear in a highly favourable light. Although they are both
representatives of the former spiritual and artistic

[76]No attempt is made to distinguish between the latter-day
non-Romantic artists; they appear as stereotypes.
Admittedly, very little space is allotted to them.

Zeitgeist, however, there are some important distinctions to be drawn between them. Indeed, the Klosterbruder's alternative is an extremely important factor when considering the relative merits of Joseph Berglinger, however much this may have been ignored up to the present.

4.2.1 The Klosterbruder's alternative

The main body of Wackenroder-criticism has considered the figure of the Klosterbruder almost exclusively within the compass of his perspective and his role as narrator.[77] There is, however, another, equally significant role which has been largely neglected. The Klosterbruder, alongside Beglinger, provides another example of the modern Romantic artist's inability to integrate with modern (rationalistic) society. Thus, we are presented with a twofold image of the modern artist's dilemma.[78]

Whereas the life-story of Joseph Berglinger is set out in some detail, that of the Klosterbruder remains somewhat nebulous. Nevertheless, a few scattered details may be gleaned from the preface, the introduction to the Berglinger-story and those sections where he focuses on his

[77] These points have been discussed sufficiently in connection with the structure and narrative framework of the *Herzensergiessungen*.

[78] Elmar Hertrich calls Berglinger and the Klosterbruder a twofold mask, behind which the author conceals his own identity. E. H., op. cit., p. 10. For details see Paul Koldewey, *Wackenroder und sein Einfluss auf Tieck* (Altona: Hammerich and Lesser), p. 96f.

own youth, especially the introductory segment of the
"Malerchronik".[79] From the preface we learn that his
uncommon love for art has accompanied him throughout his
long life. From the lonely seclusion of a monastery, he
looks back to the time of his youth, when he was still
involved in the affairs of the world. The great desire of
his young days was to devote his whole life and all of his
talents to the service of art:

> In meiner Jugend war ich in der Welt und in vielen
>
> weltlichen Geschäften verwickelt. Mein grösster
>
> Drang war zur Kunst, und ich wünschte ihr mein Leben
>
> und alle meine wenigen Talente zu widmen. (p. 9)

In the unassuming manner natural to him, he acknowledges his
own artistic gift. Unlike Berglinger, the Klosterbruder is a
graphic artist, a fact which makes him closer to the
Renaissance figures, of whom some, it must be said, were
also sculptors. Leonardo da Vinci is the only musician
amongst their number. It appears that the Klosterbruder had
once been a painter of some promise:

> Nach dem Urteile einiger Freunde war ich im Zeichnen
>
> nicht ungeschickt, und meine Kopien sowohl als meine
>
> eigenen Erfindungen missfielen nicht ganz. (p. 9)

It appears, however, that his natural modesty and his
feelings of inadequacy and inferiority before the example of
the great masters of the Italian Renaissance may have

[79]Cf. Elmar Hertrich, op. cit., p. 12.

restricted his development as an artist:[80]

> Aber immer dachte ich mit einem stillen, heiligen
>
> Schauer an die grossen, gebenedeiten Kunstheiligen;
>
> es kam mir seltsam, ja fast albern vor, dass ich die
>
> Kohle oder den Pinsel in meiner Hand führte, wenn
>
> mir der Name Raffaels oder Michelangelos in das
>
> Gedächtnis fiel. (p. 9)

Thus it would seem that the young enthusiast, like
Berglinger himself, is more suited to be an admirer of art
than a practicing artist. He confesses to having been moved
to tears whenever he contemplated the lives and works of his
heroes. The same admiration for the Italian masters is
reflected in the section entitled "Sehnsucht nach Italien",
a record of his youthful desire to visit the homeland of
art. Here we may observe the same Wanderlust or search for
art which grips Berglinger, several artists of the
"Malerchronik" and the hero of *Heinrich von Ofterdingen*. The
same urge is expressed once again in the introduction to the
"Malerchronik", where the Klosterbruder records one of his
journeys:

> Als ich in meiner Jugend mit unruhigem Geiste hier
>
> und dort umzog und überall begierig aufschaute, wo
>
> von Kunstsachen etwas zu sehen war ... (p. 99)

On this occasion, the young enthusiast finds himself in a
castle full of beautiful paintings. It is here that he makes

[80] Such modesty is reminiscent of Raphael and Dürer, and
stands in contrast to the pride of Francia, and, to a far
lesser degree, that of Berglinger.

a most significant encounter.[81] He meets a journeying
Italian father who introduces him to the lives of those who
have excelled in art, as revealed by their chroniclers. This
leads him to seek out the works of the great biographers of
artists, especially that of Giorgio Vasari, and begin his
study of the history of artists.

This is as much as we know of the narrator as a young
man. The middle period of his life remains a complete
mystery. Obviously, at some time, the growing burden of
alienation from a world which no longer appreciates the
holiness of art has driven him to seek spiritual refuge in a
monastery, where the piety of former times lives on.[82] As an
art-loving friar, he is able to combine both religion and
art, and thus may be compared to the friar-painters of the
Italian Renaissance, such as Fra Angelico da Fiesole, and to
his erstwhile mentor, the Italian father. As a voluntary
exile from society, however, one might remark that he falls
foul of his own criticism of Berglinger, in which he implied
that the artistic nature should endeavour to integrate with
the world and become part of it. On the other hand, despite
his rejection of modern society, it must be said that he
makes a positive attempt through the *Herzensergiessungen*,
the literary work of art of his old age, to encourage young

[81]One might compare this enlightening experience to
Berglinger's first visit to the city of the episcopal
residence.

[82]Berglinger expresses the desire to leave society, but
refrains from doing so. Moreover, his wish is for some form
of artistic exile with his Swiss shepherd, not the spiritual
haven of a monastery (p. 127).

admirers of art.

Clearly, the Klosterbruder is more spiritually inclined
than his young friend was in his lifetime. On the other
hand, it may be said that he is something less of an artist
figure. Moreover, although they both experience the
alienating effect of the modern attitude towards art, and
suffer because of it, Berglinger remains within society. The
Klosterbruder, however, a capable artist in his own right,
has withdrawn from society because of its prevailing
insensitivity to art. At least Berglinger, who experiences
the same dilemma, has struggled on within society to produce
something of lasting value. Nevertheless, it must be
remembered that the Klosterbruder, unlike Berglinger, does
not appear to suffer from any inherent dispositional
imbalance. The comparison with the Klosterbruder has served
to relativize the portrait of Joseph Berglinger within the
context of the modern era. On the basis of both their
examples it may be said that the Romantic artist or
enthusiast necessarily becomes isolated and alienated in the
modern era, from which he is spiritually and artistically
estranged.

4.3 Berglinger in a Renaissance perspective

As already noted, the composer Joseph Berglinger, as
well as his friend the Klosterbruder, is a spiritual
descendant of the (Italian) Renaissance, as it is portrayed

in the Renaissance vitae and the "Malerchronik". Because of
the fundamental change in the attitude of society towards
art, however, he is forced to contend with difficulties
which were virtually unknown to his spiritual forbears. Two
brief examples, one from Berglinger's youth and one from his
adult life, will serve to illustrate this point.

During his childhood, Berglinger's natural inclination
towards music is clearly restricted by his father's negative
attitude towards art. His viewpoint may be seen as a
reflection of the reduced status which is accorded to art in
the modern age. Instead of encouraging his son, he makes a
futile attempt to convert him to the study of medicine. In
this regard, Berglinger stands in contrast to the more
fortunate Renaissance artists. Jacob Callot, one of those
mentioned in the "Malerchronik", a post-Renaissance French
artist, is the only other figure in the work whose parents
actively discourage his artistic inclinations in favour of
studies in other areas. Whereas the father of Callot
eventually accedes to his son's wishes, however,
Berglinger's father remains adamant. Leonardo da Vinci,
along with several other Renaissance artists, is encouraged
to develop his artistic gifts and is apprenticed to a great
master at an early age. Berglinger, in contrast, is forced
to run away from home and seek refuge with a well-disposed
relative who arranges for his tuition. It is also worth
noting in this context that many of the Renaissance artists
appear to have enjoyed happy family lives. Berglinger's

unhappy circumstances stand in stark contrast to those of
Raphael in particular, who came from a loving, sheltered
background.

In later years, as a practicing composer and court
musician, Berglinger still suffers on account of the
diminished status of art. Although there is much pomp and
finery associated with musical performances in his day, the
artist himself is a mere shadow of his Renaissance
counterpart, a revered public figure, and can only expect
mild applause, not universal respect. This has serious
consequences in the area of free artistic expression. The
artist of the modern era appears to be largely a hired
entertainer of sorts, since he is obliged to follow the
aesthetic guidelines laid down by the court. The only
example of a Renaissance artist being treated as a
wage-earner who has to follow orders is to be found in the
vita of Leonardo da Vinci, where the great master is
reprimanded for his tardiness in completing a commission:

... worauf der Prior ... ihn, wie einen Tagelöhner,

über sein Zögern zur Rede gestellt habe. (p. 43)

It is also the great Leonardo, however, who is treated with
the greatest respect by the king of France, in whose arms he
expires.

4.3.1 Music and the Fine Arts

Although the Renaissance artists, especially the
multi-talented Leonardo da Vinci and Michelangelo, are by no
means limited to one form of art, their most significant
work is clearly in the field of Fine Art.[83] There is,
however, a common denominator in that they are all adepts of
the art of painting. Indeed, it is this art which takes
pride of place in the *Herzensergiessungen* as a whole. In the
Klosterbruder's perspective, however, it is not the form of
art which is of the utmost significance, but the object of
its representation. In one section he likens the nobler
art-works to prayer.[84] Similar sentiments are ascribed to
Fra Angelico da Fiesole of the "Malerchronik". The Italian
father of the "Malerchronik", we should remember, praises
the Renaissance artists because they portrayed holy subjects
in their works, thus commending their art to the service of
God.[85] This view is clearly shared by the Klosterbruder
himself, who accords special praise to those artists such as
Raphael, who are famous for their beautiful Madonnas and
other holy images.

[83]Many critical works deal with this theme. Perhaps most
relevant among these is that of Rose Kahnt, op. cit.
[84]The essay section entitled "Wie und auf welche Weise man
die Werke der grossen Künstler der Erde eigentlich
betrachten und zum Wohl seiner Seele gebrauchen müsse".
[85]It should be remembered, however, that several of the
Renaissance artists, even revered figures such as
Michelangelo, Leonardo da Vinci and, especially, Dürer, also
portrayed worldly subjects. Others, especially Cosimo,
produced works of a distinctly profane nature.

Whereas the Klosterbruder describes himself as being an
erstwhile painter, Joseph Berglinger, the only other
representative of the former artistic spirit in the modern
age, is an adept of music. This leads us inevitably to ask
ourselves whether Berglinger's chosen art form is to be
considered inferior in some way to that of painting.[86] Here
I would re-state my premise that it is theme or subject
matter and not the art form itself which appears to be of
prime importance. In the age of the Klosterbruder and
Berglinger, as we know from the comments of the Italian
father, the art of painting has become secularized, since it
no longer relates to religion or religious matters. This, we
could assume, is one of the major factors in the
Klosterbruder's decision to withdraw from society. The art
of music, however, appears to be closely connected with the
church. Indeed it was church music which had a profound
effect on the young Berglinger. Moreover, as Kappellmeister
in the episcopal residence, Berglinger has every opportunity
to devote his music to the service of religion.[87]

Thus, it may be suggested that music is perhaps a more
suitable medium for the Romantic artist in the modern era.
In the particular case of Berglinger, however, this
supposition may require some qualification. One of the major
criticisms levelled against him by the Klosterbruder is that

[86]As already mentioned, Leonardo da Vinci is the only
Renaissance artist credited with musical accomplishments.
[87]As previously noted, all of Berglinger's compositions
appear to be of a religious nature.

he is unable to relate sufficiently to the world about him
on account of his over-imaginative, ethereal spirit. This
tendency towards inwardness is clearly magnified by the
cerebral nature of the composer's art. Painting, on the
other hand, as a representational art form, is bound much
more closely to life and Nature, whilst music is dominated
by the world of feelings. Whereas the Renaissance artists
are forced, as observers of man and the natural realm, to
interact with their surroundings, Berglinger, who relies on
the power of his imagination to create music, is cut off
from life. Thus music appears as a more hazardous medium
than painting.

4.3.2 Berglinger and the ideal

The purpose of the present section is to determine to
what extent Berglinger approaches the Klosterbruder's
artistic ideal as exemplified by Raphael and, to a lesser
degree, by the other Renaissance greats of the
Herzensergiessungen. According to our earlier definition,
the ideal artist must embody the perfect union of artistic
creativity and Christian piety, and should receive his
inspiration directly from God. This may be expanded to
include other highly praised virtues such as modesty, moral
integrity and diligence. Berglinger, as we have observed
him, is clearly far removed from the state of perfection
achieved by Raphael himself. Nevertheless, there are certain
areas in which he may be compared quite favourably to the

Renaissance greats in general.

In terms of enthusiasm for art, one of the prerequisite qualities of the artist, Berglinger is clearly the equal of the Renaissance artists. Like them, he discovers his love for art at an early age and decides to devote his whole life to its service. His youthful enthusiasm is comparable to that of several artists listed in the "Malerchronik", who, in their earliest youth, exhibited a special dedication for their art.[88] Similar comments may be made concerning Berglinger's religious beliefs. From the very outset of the Berglinger-story it is understood that he has, like his Renaissance counterparts, a firm and profound faith. Moreover, like them, he believes firmly in the spiritual role of art. Furthermore, like several of their number, he implores the heavens for assistance, which he indeed receives, albeit to a lesser degree. In one particular respect, his faith bears comparison to that of Raphael. Just as the latter has a deep personal attachment to the Madonna, so does Berglinger feel drawn to the figure of Christ, with whom he identifies in some way. The Klosterbruder's ideal, however, also requires that the artist serve as an example of Christian values in his daily life. In this regard Berglinger appears to fall far short of the ideal. In the first "Hauptstück" of his vita at least, his inwardness appears to lead to a certain degree of callousness and a

[88]Giotto, Domenico Beccafumi, Contucci, Polidoro da Caravaggio and Jacob Callot.

lack of true Christian charity.[89] The great artists Leonardo
da Vinci and, especially, Michelangelo, however, are models
of ethical behaviour. The same is obviously true of Raphael,
Dürer and the Renaissance artists in general.

These points may serve to illustrate the argument that
Berglinger does indeed approach the ideal in some respects,
even though he is somewhat distanced from it in the final
analysis. He is far from achieving the ideal, or indeed from
attaining the same degree of perfection as Michelangelo or
Leonardo da Vinci, even though **his** art is bound more closely
to the Church. Nevertheless, he must be regarded as being
undeniably closer to the ideal than the most problematic of
the Renaissance artists. [90]

4.3.3 Berglinger and the problematic artists

As we have seen from the Renaissance vitae and the
"Malerchronik", the past also has its share of problematic
artists. Although these figures were fortunate enough to
live in an age where their chosen profession was held in
high esteem, they were unable nevertheless to contain the
imbalances in their natures. Thus, although they enjoyed
distinct advantages as opposed to Berglinger, they could not
live in complete harmony with the world. The following
comparison of the problematic Renaissance artists Francesco
Francia and Piero di Cosimo to Joseph Berglinger will serve

[89] In the second "Hauptstück" he acts charitably towards his
estranged family.
[90] Contrast Elmar Hertrich's comments, op. cit., p. 60.

to relativize still further his position within the
Klosterbruder's scale of merit.[91]

As indicated, the similarities between Francia and
Berglinger go far beyond the circumstantial. The striking
parallelism in the titles of their respective vitae is
clearly intended to alert the reader to this fact. It soon
becomes evident when one compares these two figures that
their dilemma springs, in part at least, from a common
source: enthusiasm for art. Francia, as we know, suffers on
account of the adulation which is accorded to him. Caught up
in the general enthusiasm for art of his age, he comes to
believe in his own genius. His inflated self-esteem
eventually leads to his downfall. Whereas he is more a
victim of the general enthusiasm within society, however,
the enthusiasm to which Berglinger succumbs is purely his
own. This, then, leads not to an exaggerated sense of pride
but excessive inwardness. Indeed, as an adult at least,
Berglinger realizes fully the passive role of the artist in
the creative process. In Francia's case, on the other hand,
this realization comes late in life and leads to trauma.
Unlike Berglinger, however, Francia becomes aware of his own
failings. As the Klosterbruder points out, he regains his
humility by acknowledging its loss. On balance it is
difficult to place one artist above the other, though it is
apparent that the Klosterbruder has fewer reservations in

[91]Lesser figures such as Antonio and Spinello will only be
mentioned briefly.

the case of Francia.

Francia and Berglinger are clearly similar in terms of enthusiasm. In seeking a parallel with regard to the excesses of the imagination, however, it is necessary to turn to the figure of Cosimo. Cosimo's nature is determined by an overripe imagination and a spirit which is dominated by dark and dismal elements. The result of this unhappy constellation in his disposition is a restless soul. Driven by the relentless force of his strange fantasies, he oversteps the limits of normality. [92] Berglinger also possesses a vivid imagination, yet his flights of fancy are at least of a beautiful nature ("in diesem schönen poetischen Taumel") whereas those of Cosimo are outlandish ("immer zog ein Schwarm von fremden, seltsamen Ideen durch sein Gehirn"). [93] In both cases, however, unchecked imagination leads to voluntary isolation. [94] Furthermore, they are both disturbed by contact with their fellows. Unlike Cosimo, however, Berglinger does not go to extreme lengths to avoid contact with others. Indeed, his behaviour in general is free of the type of peculiarity which Cosimo exhibits. In sum, although both artists are possessed of a powerful and lively imagination, Berglinger is an artistic outsider, spiritually apart from his age, whereas Cosimo is clearly wayward and deranged. Moreover, Berglinger is still

[92] The same may be said of Spinello.
[93] Berglinger, however, like Cosimo, does have a tendency to dwell on gloomy thoughts.
[94] It is said of both artists that they lose contact with reality and the present time.

to be considered as an artist, even though he is perhaps not
well suited to his profession. [95] Cosimo, on the other hand,
is explicitly excluded by the Klosterbruder from the ranks
of true artists. Thus it seems ill-advised to suggest, as
has been done, that Berglinger is the most problematic of
all the artist figures in the *Herzensergiessungen*. [96] At the
very least, such a statement must be qualified with the
observation that Berglinger's situation is the most
problematic of those encountered.

4.4 Conclusions

The Berglinger-novella in Wackenroder/Tieck's
Herzensergiessungen eines kunstliebenden Klosterbruders
concludes a series of portrayals of artist figures, which
endeavour to investigate the nature of artistic genius in
its various forms. In accordance with the (subsequent) views
of the "Frühromantiker", who regarded the artist as a
mediator between the divine and the worldly spheres, the
willingness and the facility to be actuated by a
supernatural and higher force constitute the pre-requisite
of all contact with art. The propensity for creative
interpretation of the higher realm manifests itself
primarily in artistic reflection. Thus F. Schlegel's
Athenäumsfragment 116:

[95]He is much more so, however, than the semi-artist Antonio.
[96]See Elmar Hertrich, op. cit., p. 60.

> Und doch kann sie [die romantische Poesie] am
> meisten zwischen dem Dargestellten und dem
> Darstellenden, frei von allem realen und idealen
> Interesse auf den Flügeln der poetischen Reflexion
> in der Mitte schweben.[97]

In the *Herzensergiessungen* artistic reflection is initiated by enthusiasm for art ("Kunstenthusiasmus") and power of imagination ("Phantasie"). Enthusiasm and imagination are the expression of unconscious impulses, which enable the artist to re-create his perception of the hidden truth in a way that is meaningful to mankind. Unbridled enthusiasm and imagination alone cannot generate artistic genius; the true artist transcends mere introspection to recrudesce in this world with an eloquent message from the divine sphere. Thus artistic genius relies initially on the powers of enthusiasm and imagination; these lead to introspection and contact with the concealed truth of the celestial realm, which is then synthesized and crystallized into a form that is intelligible to man. In exemplary cases, such as that of Raphael or Dürer, enthusiasm and imagination coalesce with pity, probity, humanity and the capacity for harmonizing the demands of the worldly and the empyrean spheres:

> ... ein Albrecht Dürer, ein schlichter
> nürnbergischer Bürgersmann, verfertigte in eben der
> Zelle, worin sein böses Weib täglich mit ihm zankte,
> mit emsigem mechanischem Fleisse gar seelenvolle

[97] *Kritische-Friedrich-Schlegel-Ausgabe*, vol. II, p. 182.

Kunstwerke ... (p. 131)

The Klosterbruder makes an important distinction between creative genius and imagination at the end of the work. The implication is that creativity comes from the divine sphere, whereas imagination is an innate quality of the individual:

> Ja, ist diese unbegreifliche Schöpfungskraft nicht etwa überhaupt ganz etwas anderes, und — wie mir jetzt erscheint — etwas noch Wundervolleres, noch Göttlicheres, als die Kraft der Phantasie? (p. 131)

This supposition is certainly upheld by the artistic discrepancy between the 'divine' Raphael and Berglinger. It implies that the problematic artist is he who has less direct contact with the divine realm than the 'genuine' artist, and in whom the qualities of artistic enthusiasm and imagination (which are necessary to provide the initial contact with the empyrean sphere) come to the fore unrestrained.

Joseph Berglinger and the other 'problematic' artists cannot attain the ideal of the genuine, ideal and divine artist, such as Raphael, because their artistic enthusiasm and imagination cannot be channelled in the appropriate direction, because the link with the upper realm is too weak. In the case of the modern artist, such as Berglinger or the Klosterbruder himself, this situation is complicated by society's general disaffection with true art.

5. Conclusion

The *Herzensergiessungen* is not simply a loosely connected collection of pieces governed by a common perspective and a common focus on art. Rather it is a complex arrangement of interconnected essays, poems and artist vitae with a firm underlying structure. The Berglinger-novella, which concludes the work, is an integral part of this intricate whole. The figure of Berglinger, therefore, should be seen within the context of this structural entity. His vita emerges as a significant turn back to the present from a nostalgic review of an idealized golden age. This confrontation with the realities of the problematic modern era constitutes the main thrust of the work. Thus it is not the glorification of the past often associated with early German Romanticism that is of prime importance, but the tragic struggle of the modern Romantic artist. Throughout the Berglinger-story one senses in the narrator a dawning awareness of Berglinger's positive example in adverse times. In spite of his inherent problems and the difficulties which he encounters, Berglinger is able to leave behind, amongst his other works, one "eternal masterpiece". Thus, he assures that something of the heavenliness and wonder of art still lives on in the troubled present.

The golden age of the Renaissance, on the other hand, is demonstrably not as perfect as one might assume from the Klosterbruder's initial comments, or indeed from the body of Wackenroder-criticism. Although the Renaissance is clearly superior to the modern age on account of its greater appreciation of art and greater religiosity, it is by no means devoid of disquieting elements. The work's multi-faceted spectrum of Renaissance artists includes not only ideal figures such as Raphael and Dürer, but also a significant proportion of ambivalent and even problematic natures. Similarly, the present time frame presents a medley of positive and negative examples, even though the latter prevail. Thus it may be inferred that the power of art is itself an ambivalent force, in as far as it acts as a catalyst on the artist's disposition, driving him even further in one direction, or causing him to oscillate, as Berglinger does, between two poles.

Through the process of comparing Berglinger to other artists of the modern and Renaissance periods, it is possible to relativize his merits and failings. Not only in terms of details such as the similarity of titles, the manner of presentation, recurring motifs such as the "pierced heart", still and raging waters, and light and darkness, but also in terms of biographical details, the vita of Joseph Berglinger echoes those of past artists, be they ideal, ambivalent or problematic. Once this comparison has been achieved, it becomes obvious that Berglinger is a

positive example of a Romantic artist who struggles on in an adverse environment. His dispositional failings are palliated by the nature of the difficulties with which he has to contend.

6. Bibliography

6.1 Primary Texts

Novalis (Friedrich von Hardenberg). *Monolog, Die Lehrlinge zu Sais, Die Christenheit oder Europa, Hymnen an die Nacht, Geistliche Lieder, Heinrich von Ofterdingen.* Ed. Ernesto Grassi. Reinbek: Rowohlt, 1963.

Schlegel, Friedrich. *Kritische-Friedrich-Schlegel-Ausgabe.* Ed. Ernst Behler. Munich, Paderborn, Vienna: Schöningh; Zurich: Thomas, 1979.

Tieck, Ludwig. *Werke in vier Bänden.* Ed. Marianne Thalmann. Munich: Winkler, 1963.

Wackenroder, Wilhelm Heinrich. *Werke und Briefe.* 1797; rpt. Heidelberg: Schneider, 1967.

Wackenroder, W. H. and L. Tieck. *Herzensergiessungen eines kunstliebenden Klosterbruders.* Leipzig: Insel, 1921.

Wackenroder, W. H. and L. Tieck. *Herzensergiessungen eines kunstliebenden Klosterbruders: together with Wackenroder's contributions to the 'Phantasien über*

die Kunst für Freunde der Kunst.' Ed. A. Gillies.
Oxford: Blackwell, 1948.

Wackenroder, W. H. *Fantaisies sur l'art par un religieux ami
de l'art.* Translated by Jean Boyer. Paris: Editions
Montaigne, 1945.

Wackenroder, W. H. *Sämtliche Schriften.* Munich: Rowohlt,
1968.

Wackenroder, W. H. and L. Tieck. *Herzensergiessungen eines
kunstliebenden Klosterbruders.* Ed. Richard Benz.
Stuttgart: Reclam, 1979[3].

6.2 Secondary Texts

Alewyn, Richard. "Wackenroders Anteil an den
Herzensergiessungen und den *Phantasien.*" *Germanic
Review,* 19 (1944), 48—58.

Arendt, Dieter. "W. H. Wackenroders novellistische Erzählung
'Das merkwürdige musikalische Leben des Tonkünstlers
Joseph Berglinger'." In *Der 'poetische Nihilismus'
in der deutschen Romantik: Studien zum Verhältnis
von Dichtung und Wirklichkeit in der Frühromantik.*

Tübingen: Niemeyer, 1972, pp. 303—16.

Behler, Ernst. "Friedrich Schlegels Theorie der
Universalpoesie." *Jahrbuch der deutschen
Schiller-Gesellschaft*, 1 (1967), 211—52.

Dischner, Gisela and Richard Faber (eds.). *Romantische
Utopie — Utopische Romantik*. Hildesheim:
Gerstenberg, 1979.

Frey, Marianne. *Der Künstler und sein Werk bei W. H.
Wackenroder und E. T. A. Hoffmann*. Bern: Lang, 1970.

Fricke, Gerhard. "Wackenroders Religion der Kunst." In
*Studien und Interpretationen. Ausgewählte Schriften
zur deutschen Dichtung*. Frankfurt am Main: Menck,
1956, pp. 186—213.

Furst, Lilian R. *Romanticism*. London: Methuen, 1969.

Hammer, Dorothea. "Die Bedeutung der vergangenen Zeit im
Werk Wackenroders unter Berücksichtigung der
Beiträge Tiecks." Diss. Frankfurt am Main, 1961.

Haym, Rudolf. *Die Romantische Schule. Ein Beitrag zur
Geschichte des deutschen Geistes*. 1870; rpt.
Hildesheim: Olms, 1961.

Hertrich, Elmar. *Joseph Berglinger: Eine Studie zu Wackenroders Musiker-Dichtung*. Berlin: de Gruyter, 1969.

Hofe, Gerhard vom. "Das unbehagliche Bewusstsein des modernen Musikers: Zu Wackenroders *Berglinger* und Thomas Manns *Doktor Faustus*." In *Geist und Zeichen: Festschrift für Arthur Henkel*. Eds. Herbert Anton, Bernhard Gajek and Peter Pfaff. Heidelberg: Winter, 1977, pp. 144–56.

Horton, Gudrun Stengel. "Die Entstehung des Mittelalterbildes in der deutschen Frühromantik: Wackenroder, Tieck, Novalis und die Brüder Schlegel." Diss. Washington, 1973.

Hughes, Glyn Tegai. *Romantic German Literature*. London: Arnold, 1979.

Kahnt, Rose. *Die Bedeutung der bildenden Kunst und der Musik bei W. H. Wackenroder*. Marburg: Elwert, 1969.

Kohlschmidt, Werner. "Der junge Tieck und Wackenroder." In *Die deutsche Romantik*. Ed. Hans Steffen. Göttingen: Vandenhoeck and Ruprecht, 1967, pp. 30–44.

Koldewey, Paul. *Wackenroder und sein Einfluss auf Tieck*.

Altona: Hammerich and Lesser, 1904.

Lillyman, William J. "Tieck and Wackenroder: The common mask." In *Reality's Dark Dream: The Narrative Fiction of Ludwig Tieck*. Berlin, New York: de Gruyter, 1979, pp. 42–60.

Lippuner, Heinz. *Wackenroder/Tieck und die bildende Kunst: Grundlegung der romantischen Aesthetik*. Zurich: Juris, 1965.

Mittner, Ladislao. "Galatea. Die Romantisierung der italienischen Renaissancekunst und -dichtung in der deutschen Frühromantik." *Deutsche Vierteljahrsschrift*, 27 (1953), 555–81.

Nahrebecky, Roman. *Tieck, E. T. A. Hoffmann, Bettina von Arnim: Ihre Beziehung zum musikalischen Erlebnis*. Bonn: Bouvier, 1979.

Pikulik, Lothar. *Romantik als Ungenügen an der Normalität: Am Beispiel Tiecks, Hoffmanns, Eichendorffs*. Frankfurt am Main: Suhrkamp, 1979.

Polheim, Karl Konrad. "Studien zu Friedrich Schlegels poetischen Begriffen." *Deutsche Vierteljahrsschrift*, 35 (1961), 363–98.

Proskauer, Paul Frank. "The Phenomenon of Alienation in the
 Work of Karl Philipp Moritz, Wilhelm Heinrich
 Wackenroder and in *Nachtwachen* von Bonaventura."
 Diss. Columbia, 1966.

Ribbat, Ernst. *Ludwig Tieck: Studien zur Konzeption und
 Praxis romantischer Poesie.* Kronberg/Taunus:
 Athenäum, 1978.

Richards, Ruthann. "Joseph Berglinger. A radical composer."
 Germanic Review, 50 (1978), 124–39.

Robson-Scott, William Douglas. "Wackenroder and the Middle
 Ages." *Modern Language Review*, 50 (1955), 156–67.

Sanford, David Bruce. "Wackenroder and Tieck: The aesthetic
 breakdown of the Klosterbruder ideal." Diss.
 Minnesota, 1966.

Schrimpf, Hans Joachim. "W. H. Wackenroder und K. Ph.
 Moritz. Ein Beitrag zur frühromantischen
 Selbstkritik." *Zeitschrift für deutsche Philosophie*,
 83 (1964), 385–409.

Schubert, Mary Ethel Hurst. "Wilhelm Heinrich Wackenroder's
 Confessions and *Phantasies*: Translated and annotated
 with a critical introduction." Diss. Stanford, 1970.

Schulz, Eberhard Wilhelm. "Der mittelalterliche Künstler in
 Tiecks Roman *Franz Sternbalds Wanderungen*." In *Wort
 und Zeit: Aufsätze und Vorträge zur
 Literaturgeschichte*. Neumünster: Wachholtz, 1968,
 pp. 35—48.

Staiger, Emil. "Das Problem des Stilwandels." *Euphorion*, 55
 (1961), 225—41.

Thornton, Karin. "Wackenroder's Objective Romanticism."
 Germanic Review, 37 (1962), 161—73.

Walzel, Oskar. "Die Sprache der Kunst." *Jahrbuch der
 Goethe-Gesellschaft*, 1 (1914), 3—38.

Waniek, Erdmann Friedrich. *Moritz-Wackenroder: Zur
 Problematisierung des Künstlerischen Bewusstseins*.
 Diss. Oregon, 1972.